ANIMATION UNLIMITED

ANIMATION UNLIMITED

Innovative Short Films Since 1940

Liz Faber and Helen Walters

LAURENCE KING PUBLISHING in association with HARPER DESIGN INTERNATIONAL an imprint of HarperCollins*Publishers*

Published in 2003 by Laurence King Publishing Ltd
71 Great Russell Street
London WC1B 3BP
United Kingdom
Tel: +44 20 7430 8850
Fax: +44 20 7430 8880
e-mail: enquiries@laurenceking.co.uk
www.laurenceking.co.uk

Distributed in North and South America by:
Harper Design International
an imprint of HarperCollins*Publishers*
10 East 53rd Street
New York, NY 10022
Fax: (212) 207-7654

A catalogue record for this book is available from
the British Library

ISBN 1 85669 346 5

Designed by Nathan Gale

Printed in China

CONTENTS

INTRODUCTION

Mention the word 'animation' and you are certain to provoke myriad different responses. For some, animation means Disney, *The Simpsons*, *Monsters, Inc.* and other cartoons beloved by children's television programmers. At the other end of the scale are complex, abstract and often obscure films, aimed at an adult market, and occupying a space between filmmaking, art and graphic design. Linked only by the spirit of innovation that went into making them, these films are more often than not entirely independently produced and can incorporate a fantastic range of materials, from paint and photography to sand and dead moths. It is these experimental films that this book sets out to celebrate, those works of passion that cannot be easily categorized but that genuinely deserve wider recognition and respect.

The Oxford English Dictionary defines animation as, 'the technique of filming successive drawings or positions of puppets or models to create an illusion of movement when the film is shown as a sequence'. Artists have been interested in creating that illusion of motion since time immemorial. Primitive attempts at animation include the thaumatrope, a picture disc suspended on a piece of string, which was in wide circulation by 1826. As the disc was spun round, the image on one side – a bird – appeared to meld with the image on the other – a cage. Richard Llewellyn, life sciences librarian at Iowa State University, US (see his chronology of animation, available online at www.public.iastate.edu/~rllew/chrnearl.html), explains: 'Nineteenth-century inventions were at first part of the analysis of movement that has fascinated philosophers and physicists for centuries. The inventions were made to illustrate scientific arguments but were quickly adopted as playthings. At about the same time other scientists who were interested in other optical inventions were creating photography. The combination of these two strains ... led to the development of the motion picture camera and projector.' Flip-books of linked graphic images are still popular today, cropping up at graphic design degree shows with annual regularity. The exclusive fashion style publication *Visionaire* even got in on the act recently, printing Issue 39 as a series of sixteen flip-books designed by various top contemporary artists, fashion designers and film directors.

Early pioneers were thrilled with the potential of animation, but from early on in the 20th century divisions and tensions appeared between the commercial and the experimental. Oskar Fischinger's experiences at the hands of the Hollywood studios are perhaps indicative of what went on – and what still happens. Having made several short films in his native Germany, now widely considered to be seminal moments in experimental filmmaking, Fischinger came up with a project to make an abstract feature film based entirely on the music of J.S. Bach. Having mentioned this idea to Walt Disney, he was hired to design the Bach section of Disney's *Fantasia*. But Fischinger's experiences of working in a big studio were unhappy, to say the least, as he found the experience uncreative and impersonal.

It seems that experimental filmmakers often struggle to find their place within an industry more interested in producing entertainment product for the masses. Fischinger and the other filmmakers featured in this book exist in a rather different realm: compelled to innovate and experiment, in the main they stand to one side of the wider industry around them. Fischinger himself continued to try to raise the money to create his own films but eventually became disillusioned, abandoning experimental filmmaking and animation altogether and devoting himself instead to painting.

'Clearly the experimental tradition, that of Fischinger, Len Lye or Robert Breer, is hardly known at all to the wider public,' comments David Curtis, who runs the British Artists' Film and Video Study Collection, based at Central Saint Martin's College of Art and Design in London, and who has devoted much of his career to the preservation and archiving of such experimental films.

'But in this its fate is no different from that of the work of other artists and experimental filmmakers. Patterns of film distribution and exhibition have always been dominated by the industry majors, and have never worked to the benefit of individual creators. Even in the age of publicly-owned TV, such work is relegated to the margins, if it's aired at all.'

Animation also seems to suffer from its own limitless potential. There are so many different techniques and materials available to artists that there could never be one final, clear definition of what it is, let alone one central repository for it all. Meanwhile, many of the artists who are experimenting with animation do not define themselves as 'animators' as such but are interested in pursuing entirely new routes of creativity and expression. Croatian director Borivoj Dovnikovic, for example, describes himself as 'a caricaturist, illustrator, comic strip designer, graphic designer and animation filmmaker (script-writer, designer, animator and director)', and this interest in multi-tasking and disinterest in being pigeonholed are typical.

Jan Svankmajer, the celebrated Czech Surrealist artist and animator, explains: 'Animation itself is not an art form, but a means of expression that one can put at the service of artistic creativity, but also at the service of business. Animation has certain expressive capabilities: it can, for instance, bring inanimate things (artefacts) to life. This basically magic aspect of animation brings it closer in especially inspired moments to the proximity of poetry.' He continues: 'I am still convinced that poetry is the foundation of all forms of art, that it stands in their centre and all the rest are but means for grasping it. That also applies to animation. The means are interchangeable. The creators of animated films who lock themselves into the realm of their specialization are too imprisoned by animation techniques and become like Do-It-Yourself enthusiasts.'

Certainly, computer technology has brought something of a revolution in animation over the past few years, and much as anyone with a computer or a sequencer can now be a designer or a musician, so, too, can anyone now be an animator. As with design and music, this has not always been for the good of the medium, as Dutch-Canadian animation director Paul Driessen explains: 'New technology has meant that some really dreadful work has been produced – anyone can do it but they're not good filmmakers.' He continues: 'Sometimes when all the bad experiments are done by the computer it is hard to tell a good artist from a bad one. Sometimes with computers it is hard to draw the line between what is an animated film and what is not.'

However, as director Paul Glabicki argues, the computer does not mean the end of innovation. Instead its potential can be harnessed to co-exist alongside 'traditional' animation. 'Computers are wonderful tools that offer new options and creative choices for animators, but this technology does not diminish the rich legacy of animation cinema,' he says. 'I happen to have navigated through about 35 years of technological change in my own work and I feel very fortunate to have this experience. I never abandoned my earlier work, techniques or love of pre-digital formats. They have enriched and informed my thinking about animation and temporal composition. I can draw with a pencil, paint with a brush or move a mouse to navigate through my creative interests and process.'

By its very nature, animation can be a painstaking business – many of the films featured in this book took years to complete – and this is perhaps why the short film remains a favoured medium for artists wishing to experiment or innovate. Clare Kitson, who ran the animation department at Channel 4, one of the UK's five terrestrial television stations, and who was responsible for commissioning many of the shorts broadcast on the channel, explains: 'Animation is somehow concentrated and intense, it can say a lot more in a short time. It takes a lot of concentration from an audience. I'm not a very big fan of feature animation because, in order for it to be watchable over the long haul – not to mention affordable – it has to be really simplified.' Borivoj Dovnikovic is equally enthusiastic about the genre: 'I can only satisfy my artistic needs with short animated films,' he explains. 'I don't like to work on animated serials or feature films as I don't wish to be a slave to animation, and short films allow me to pursue my interests in other fields such as caricature, illustration and graphic design.' Michael Scroggins, director of the computer animation labs in the School of Film and Video at the California Institute of the Arts (CalArts) in

Los Angeles, agrees: 'There is a long history of innovation in animated short films in forms as far ranging as the absolute animation of Oskar Fischinger and the cartoon animation of Tex Avery. The field continues to grow and the large output of short films is indicative of a rich culture not wholly dependent upon the economics of mainstream entertainment.'

However, a lack of funding for animation means that short films are often the only economically viable medium for a newer, less established director to pursue. National organizations such as the General Post Office (GPO) Film Unit in Britain and the National Film Board (NFB) of Canada have financed films by Len Lye and Paul Driessen, respectively, although these are the exception rather than the rule. As such, many directors have to supplement their personal work through advertising commissions. Jonathan Hodgson, for instance, founded his commercial studio, Sherbet, in order to work on advertising projects but is currently trying to set up a scheme to commission short films from young directors. 'If we see someone who's brilliant and just getting started we can give them some money to develop their work and then hopefully promote them and get work back. It's a way of tying people to the company but it wasn't something that was offered to me,' he explains. 'Funding has got to come from somewhere, and I want Sherbet to act almost like a commercial patron. That's what commercials are useful for – you take the money you get paid for them and you put it back into art.'

Animation directors have often suffered in terms of how they are perceived, particularly in the West. Directors in countries such as Croatia and Russia are officially considered artists and readily accepted as part of the arts intelligentsia. Elsewhere, however, an animator's status is rather more confused. Although video art has become a more widely accepted part of the fine art world over the past number of years, animation has still not really been afforded a place on the rostrum. Again, it seems that Disney and his ilk have a lot to answer for, unwittingly influencing opinion to such an extent that there seems to be no room in the public consciousness for any other kind of animation. American director George Griffin has been creating cartoons and 'anti-cartoons' since the 1970s. He wryly refers to Disney as 'that Oedipal father figure: at some point you either have to kill him or join him'. As for the art world, director Paul Glabicki comments: 'A few individuals have managed to "break through" into the art mainstream (Robert Breer, John Whitney Snr. or, most recently, William Kentridge). Kathy Rose surfaced by emerging from the world of 16mm film by combining her animation with live performance and dance. Still, so much wonderful work has never received attention. Worse, great work by many outstanding animation artists (especially from the rich explosion of talent that peaked in the 1970s) is virtually forgotten or impossible to access.'

Indeed, much of director Ed Emshwiller's work has survived only thanks to the quick thinking and dedication of William Moritz and Michael Scroggins of CalArts, who once realized to their horror that boxes containing Emshwiller's films were about to be thrown away. 'We loaded the work on to a dolly and carted it down to a storeroom in the School of Film and Video. Eventually that room was needed for other purposes and so Bill arranged to have the material taken down to the iotaCenter [Research Library and Media Collection, Los Angeles] for archiving,' explains Scroggins. 'I personally found the very short-sighted and callous disregard for the value of the collection of Emshwiller's materials disheartening. I am happy to know that the materials have a home at the iotaCenter.'

Another difficulty for the prominence of animation is that public viewings are rare. Cels or still frames from animated films are sometimes put on display in a gallery, but this never really conveys the whole point or beauty of a film, while digital films obviously have no physical entities whatsoever. Historically, animated shorts often appeared at the beginning of a feature film presentation, but that rarely happens now. 'For years I had a strong belief that animation would get a bigger audience,' says Erica Russell. 'But people just don't get to see it.' Perhaps the Internet will supply one solution to this problem, as film distributors are now able to access a global market for such films. 'Technology is now beginning to be helpful,' says David Curtis. 'Some artist-run and even commercial gallery spaces are showing animation, thanks to the ease and reliability of DVD players. Angus Fairhurst and Ann Course are artist-animators who have shown in this context. And it is beginning to be possible for the public to buy collections of work

by Lye, Breer, Fischinger, the Quay brothers *et al* on video and DVD, through the enterprise of publishers such as Editions Re:Voir and the BFI [British Film Institute]. But it's not yet a fully fledged artistic economy.'

While some animation directors remain a little hurt that their status as artists isn't always entirely appreciated, that's certainly not going to stop them from creating their films. As director Tim Hope explains: 'The great thing about computer animation is that in the end you're so self-sufficient. I'm never going to be waiting for funding or for some TV boss to decide that they like me, I can just get on making what's in my head.' He continues: 'Animation is people wanting to make films who don't have the facility to do it the "right" way. Which is good. Animation is unlimited: when you get it right, it is a phenomenal, direct form of communication.'

Animation festivals held in international venues as diverse as Annecy, Hollywood, Hiroshima, Bristol and Zagreb continue to celebrate the medium and the short – and full-length – film genre, while galleries now feature animation films more regularly. Tate Modern in London, for example, includes a film by Jan Svankmajer in its permanent collection. Animated feature films aimed at an adult audience – such as Richard Linklater's *Waking Life* – are also becoming more common, while the ongoing, sterling efforts of David Curtis in the UK, Larry Cuba and Cindy Keefer at the iotaCenter in the US and various national organizations such as the NFB of Canada mean that efforts are being made to catalogue and archive these experimental *tours de force*.

The films featured in this book represent only a tiny cross-section of works and directors from around the world. Another book featuring entirely different films by different filmmakers could have been produced simultaneously, but with our editorial choice we have attempted to cover the most important era of animation history to date. We have also deliberately set early works by pioneers such as Len Lye and Norman McLaren next to films by younger, more contemporary artists to showcase a wide variety of styles and techniques. In our attempts to celebrate the diversity of the genre, we restricted ourselves to choosing one film per artist, and where possible we have included at least an extract from that film on the book's accompanying DVD so that you can see the films in all their moving glory. This has not always been possible – film rights are such a complicated issue that in some cases we were unable to clear even an extract, for which we can only apologize.

These are films created by an irreverent and unrelated group of filmmakers who are not interested in what they ought to be doing to further their careers nor in what might earn them the most money and who do not consider where the film might ever be shown once it is finished. This passion and genuine creativity should be both saluted and celebrated, and it is our pleasure and honour to present this series of films, all of which were created in circumstances such as these.

Liz Faber, London
Helen Walters, New York

Form explores the motion and graphic techniques that have been used in animation and how these have often led to the creation of a more abstract type of film. Animators are often wildly inventive with the tools they have at their disposal. Alexander Alexeieff and Claire Parker's *The Nose* (1963) was produced using their own unique animation technique, the pinscreen. The duo achieved a three-dimensional effect by pushing pins in and out of a screen to create variations in tone, from black to white and grey.

Filmmaker Jules Engel similarly used form to explore the use of animation as a visual language. He describes his work as 'art in motion', conveying ideas and emotions through form and colour, as featured in *Train Landscape* (1974). Erica Russell's *Triangle* (1994) is also an exploration of art in motion. In this film three human figures, locked in an eternal triangle, are wonderfully captured through the use of stencils.

FORM

Paul Glabicki however, plays with the very nature of form itself, taking recognizable objects from everyday life and reducing them to their minimum geometric components, before reconstructing them again. In *Full Moon* (2001) he uses this approach to explore an 'imaginary universe of art, nature, beauty, poetry and science'. Collective Insertsilence also toy with the definition of form: '*Aug 16th* (2001) was the result of a desire to 'play animation as if it were music', explains one half of the partnership, James Paterson.

Many animators have explored 'direct' filmmaking, working directly on to filmstock to construct their work. Direct films can be made by marking, scratching, exposing and painting the film. For *Mothlight* (1963) Stan Brakhage actually pressed dead moths and grasses between sheets of film. Len Lye's film *Color Cry* (1952) was created by applying and then exposing stencils and other objects directly on to the film.

Perhaps most ambitious of all are the animators who have sought to use computers and mathematics to construct their films and break new ground. One such acclaimed director is Ed Emshwiller, whose *Sunstone* (1979) was the first, painterly, digital computer-graphics film. *Sunstone* also features the first ever three-dimensional object on film, a cube rotating in space. This was accomplished several years before commercially viable 3D computer hardware and software systems became available.

John Stehura worked on a mainframe computer, which didn't even have a screen, to generate his psychedelic classic *Cibernetik 5.3* (1960–65). For Stehura, the excitement lay in not knowing what was going to come out of the machine. 'I wanted to see if I could create some semblance of a mind,' he explains. 'Our own imagination is frequently limited, usually greatly influenced by our memories, consequently easily anticipated, while machines, when designed to be cognitive, can greatly expand our visions, even our technical understanding and ultimately extend our own personal horizons.' Similarly, American animation director Karl Sims, whose film *Panspermia* (1990) is featured here, uses the computer to create outcomes he himself would never have imagined.

Japanese animator Yoichiro Kawaguchi takes this yet further. Using computers to create his films, such as *Eggy* (1991), he attempts to give human intelligence to abstract form. He constructs his films from a cyberspace in which virtual creatures evolve and die. To do this he created a computer program called Growth Model based on growth algorithms. Should Kawaguchi succeed in adding intelligence to these forms, he believes that the resulting interaction will fundamentally change our appreciation and experience of art and of animation itself.

TITLE
Color Cry

DIRECTOR
Len Lye

COUNTRY OF ORIGIN
USA/New Zealand

MUSIC
Fox Hunt by blues musician
Sonny Terry

TECHNIQUE
Direct film, 'Shadowcast'

FORMAT
16mm, colour

LENGTH
3 minutes

YEAR
1952

WEBSITE
www.govettbrewster.com

New Zealand poet Alistair Reid described Len Lye as 'the least boring person who ever lived'. Certainly, Lye was prolific: a filmmaker, kinetic sculptor, photographer, writer and eccentric, he also, among other things, invented ways to make films without a camera.

Lye was born in Christchurch, New Zealand, in 1901. When he was young he made a close study of the art of the Maori, the indigenous people of New Zealand. In the early 1920s he spent several years in Australia and the South Pacific Islands, such as Samoa, where he studied the dance rituals of the Australian aborigines and of Polynesia. While he was in Australia he became involved with filmmaking, which he saw as an ideal medium for his 'art of motion'.

Lye left New Zealand for London in 1924, where his breakthrough came in 1934–35 when he discovered that he could make films by drawing directly on celluloid, pioneering a method known as 'direct' filmmaking. This discovery was born out of necessity, because at the time he could not afford to hire a film camera. He found he could create 'pure figures of motion' by painting, stencilling or scratching directly on film. With the right ink and brush he could (to use Paul Klee's phrase) 'take a line for a walk' or make it dance along a strip of film.

Animator Norman McLaren had started to use a similar method around the same time as Lye, but it was the impact of Lye's hand-painted film *Colour Box* (1935) that persuaded McLaren to apply himself seriously to making such films. Many other animators have since used the idea in their own way.

In 1944 Lye moved to New York, where he contributed to the upsurge in experimental filmmaking that was taking place in the US. In the 1940s and 1950s he came to know many of the abstract expressionist artists who screened his films at their parties, and he felt a great affinity between their paintings and his films. Throughout his 50-year career as a filmmaker Lye saw animated film as a perfect medium for experimentation. He wanted animators to be 'free radicals' and once wrote: 'There has never been a great film unless it was created in the spirit of the experimental filmmaker. All great films contribute something original in manner or treatment.'

Lye was also a pioneering 'kinetic sculptor', making his first experiments in the early 1920s. He saw his work in film and kinetic sculpture as part of the same attempt to develop a new art of motion. He first exhibited his sculptures at the Museum of Modern Art in New York in 1961 and subsequently took part in many group exhibitions in both North America and Europe. He wanted to build giant versions of his sculptures in open landscape to 'pay homage to the energies of nature', and he left detailed plans and instructions for this to be done. Today, years after his death in 1980, the Len Lye Foundation is building these giant works in New Zealand.

In 1992 Lye was honoured as one of the 100 great innovators of 20th century art in a major exhibition in Germany, which also featured the work of Pablo Picasso, Marcel Duchamp and Constantin Brancusi.

Color Cry (1952) is one of many types of direct film made by Lye. For this particular one he acknowledged the precedent of Man Ray's 'rayogram' or 'shadow cast' technique, by which strips of 16mm film were exposed in a dark room. Lye developed Ray's method in his own way by covering the film strips with fabrics, stencils, colour gels and various unlikely objects.

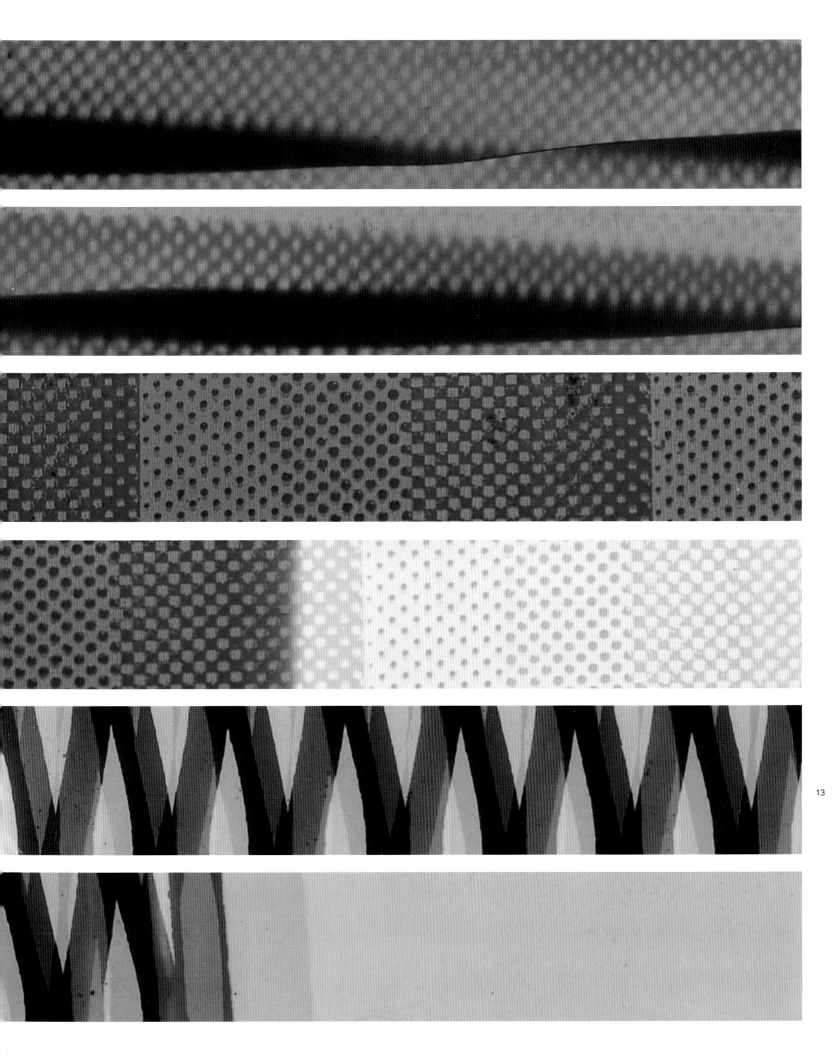

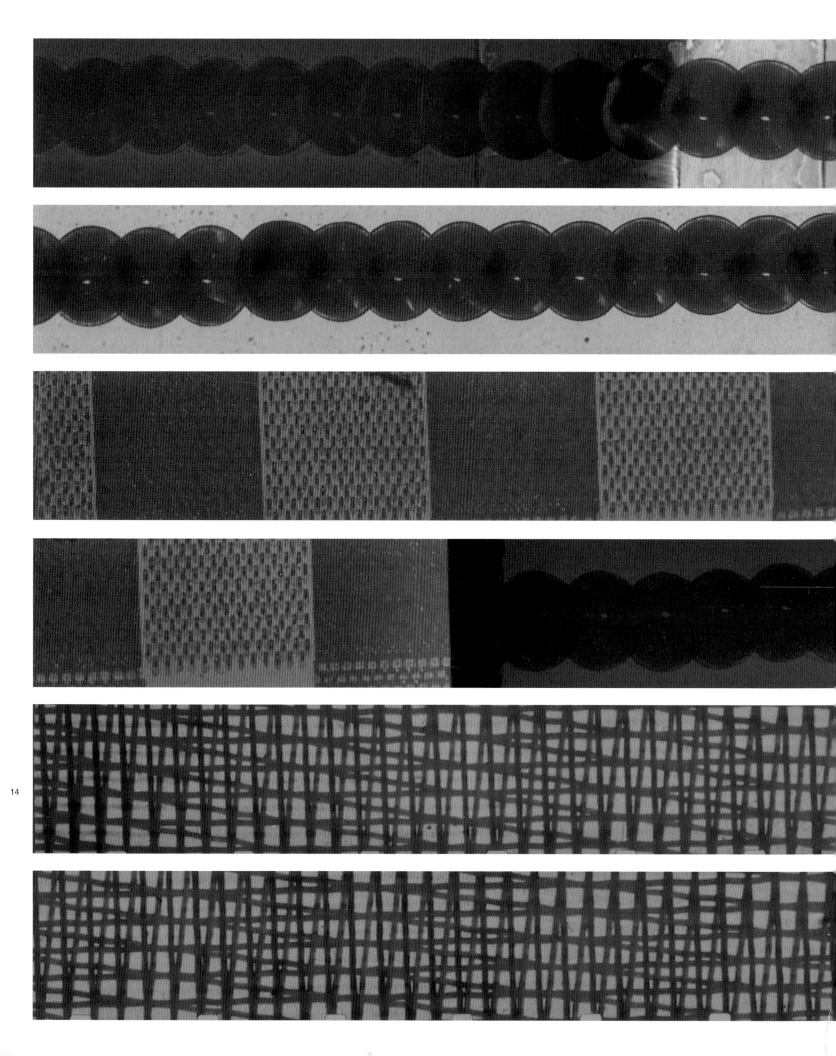

TITLE
The Nose

DIRECTORS
Alexander Alexeieff and
Claire Parker

COUNTRY OF ORIGIN
France

TECHNIQUE
Pinscreen

FORMAT
16mm, black & white

LENGTH
11 minutes

YEAR
1963

Alexander Alexeieff was born in Kazan, Russia, in 1901, and his love affair with movement began when he was a small child, brought up on the shores of the Bosporus, where he would watch the boats coming and going. His relationship with music began a little later, when he would lie awake at night, afraid of the dark, listening to his mother play the piano and imagining 'black knights on black horses coming towards me at the pace of the music'.

When he was 20 Alexeieff moved to Paris, where he worked in the theatre as a set designer, collaborating with several celebrated directors and also working with the Ballet Russe. When he was 25 years old he abandoned the theatre and began to learn about illustration, teaching himself how to make prints, and he was soon enjoying success and earning good money, mainly because his style was unusual. 'I thought I was a big artist,' he said. 'But I wasn't happy because I kept on repeating myself. This is what happens … an artist has to change, explore and take risks.'

It was in Paris in 1932 that Alexeieff met Claire Parker. She was born near Boston, Massachusetts, in 1906 and had travelled to Paris to find her future. A boyfriend gave her some books illustrated by Alexeieff, and she was so impressed that she contacted the publisher, asking to meet him. 'I figured I would meet an old, dignified man with a white beard,' she recalled. 'But I saw this tall, brown, handsome, aristocratic, 30-year-old guy. Our first lesson ended on the banks of the Seine, hand in hand; and there was never a second one.'

The couple were married in 1941 and began a lifelong collaboration that spanned some 50 years. She became the cinematographer and music synchronizer, while he was the image-maker and story-teller. Inspired by books, paintings, ballet and the cinema, Alexeieff and Parker wanted to create pictures that transformed themselves by using a process that, they understood, was not the same as illustrating a printed page.

Their first film, *Night on Bald Mountain* (1933), was based on the symphonic poem *Night on the Bare Mountain* by the Russian composer Modest Mussorgsky. While they were making the film they would listen to the music again and again: 'We understood that the images of the film had to come from the previous images – the film was conceived and built chronologically.' To generate the dark imagery of ghosts, goblins and other unearthly monsters they invented their own animation technique, the pinscreen. The animators pushed pins into and out of a screen, creating variations from black and white to shades of grey that resulted in a compelling three-dimensional effect. *Night on Bald Mountain*, the first film to be made in this way, took a total of 16,000 images and one and a half years to complete.

Alexeieff and Parker also made many successful commercials and other short films, which were often based on classic Russian stories and music. *The Nose* (1963) was based on a story by Nikolai Gogol, while both *Pictures at an Exhibition* (1972) and *Three Moods* (1980) were again based on music by Mussorgsky. Alexeieff and Parker died one year apart, she in 1981 and he in 1982.

The Nose (1963) is based on a surreal story, written in 1836 by Nikolai Gogol. It tells of a barber who discovers a disembodied nose in a loaf of bread. The film was made using the pinscreen technique invented by Alexeieff and Parker.

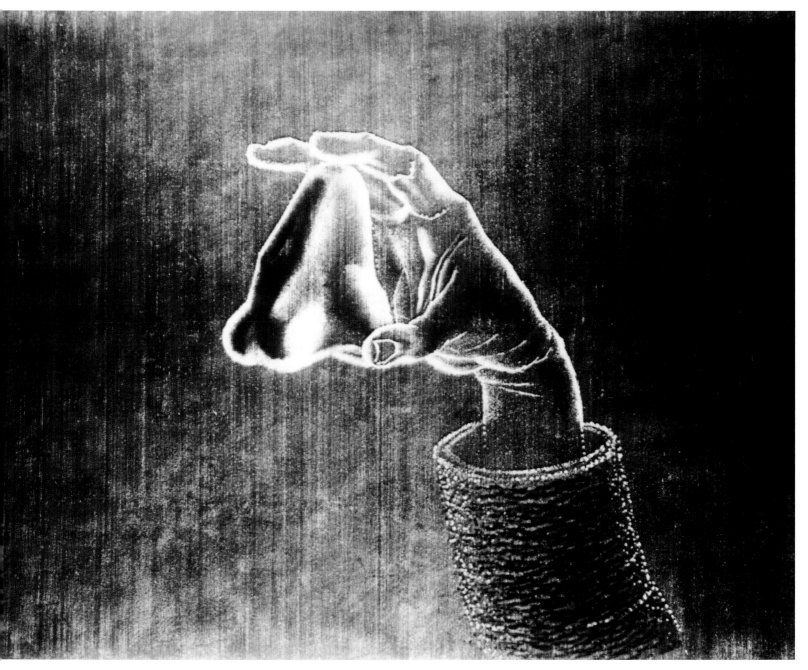

TITLE
Mothlight

DIRECTOR
Stan Brakhage

COUNTRY OF ORIGIN
USA

AWARDS
Brussels International Film Festival, 1964; Spoleto Film Festival, 1966

TECHNIQUE
Direct film

FORMAT
35mm, colour

LENGTH
4 minutes

YEAR
1963

Stan Brakhage was born in Kansas City, Missouri, in 1933 and educated at Dartmouth College, New Hampshire. He dropped out in 1951 while still a freshman to concentrate on his filmmaking. In a long career he made more than 250 films using a variety of techniques, from directly scratching and painting on film to baking it or even etching on to its surface.

Many of Brakhage's films are silent, and they vary in length from nine seconds to four hours. They are linked, however, by the exploration of a common theme: the concept of vision and the act of perception. Brakhage wanted his viewers to be touched in the 'very flesh of our eyes', and his work is dedicated to exploring the furthest possibilities of filmmaking in this context.

Brakhage's films are enormously precise, but his filmmaking techniques were anything but conventional. In particular, he used many different methods to try to recreate the state between being asleep and awake (what he called 'hypnoagogic' vision). He also frequently incorporated images of babies, animals and insects into his films. In an interview celebrating his sixtieth birthday, Brakhage said: 'My cutting has always tried to be true to the eyes, to the nervous system and to memory, and to capture these processes, which happen very rapidly.'

For many years Brakhage and his wife and children lived in a log cabin near Boulder, Colorado. The surrounding countryside and his closeknit family life clearly influenced many of the films; recurring subjects included 'love-making, childbirth, children's play, mountains in a snow storm, potted plants, forest fires, trips to town and even journeys around the world'. His 1963 film *Mothlight* was his first experiment at making a collage on film: he pressed moth wings, flower petals and blades of grass between two clear strips of film. These were then re-photographed through an optical printer.

In the opening of his 1963 book *Metaphors on Vision*, Brakhage asks his reader to 'imagine an eye unruled by man-made rules of perspective, an eye unprejudiced by compositional logic, an eye which does not respond to the name of everything but which must know each object encountered in life through an adventure in perception. How many colours are there in a field of grass to a baby unaware of "green"?'

Brakhage also lectured extensively at universities, colleges and film festivals around the world. In addition to public lecturing, he taught film history and aesthetics between 1969 and 1981 at the School of the Art Institute of Chicago, US. From 1981 he taught in the Department of Film Studies at the University of Colorado at Boulder. Brakhage died in 2003.

Mothlight (1963) was made when Brakhage was so poor that his camera was in the pawnshop and he had no money for filmstock. Instead, he pressed various objects between two clear strips of film and managed to persuade his local image lab to process this 'nature sandwich' through the film printer. Half of the footage was processed and became *Mothlight*. Brakhage described the film as 'what a moth might see between birth and death'.

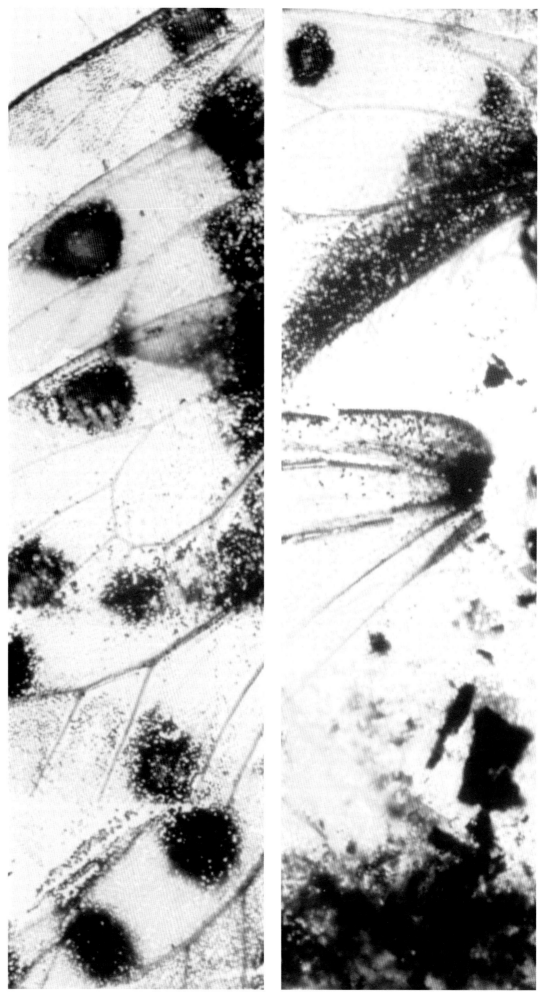

19

TITLE
Cibernetik 5.3

DIRECTOR
John Stehura

COUNTRY OF ORIGIN
USA

MUSIC
Tod Dockstader

TECHNIQUE
Cybernetic animation

FORMAT
16mm, colour

LENGTH
8 minutes

YEAR
1960–65

WEBSITE
http://cyberanimation.tripod.com

John Stehura was born in the US in 1943. When he was 17 years old he went to the University of California, Los Angeles (UCLA) and within a few days of starting the course he began work on the creation of a system for computer animation. During that time Stehura originated numerous image-processing algorithms that could automatically design, transform and render three-dimensional images using genetic and artificial intelligence control mechanisms. This resulted in one of the first ever computer motion pictures, *Cibernetik 5.3* (system 5, version 3), which was produced soon after the first digital film recorder became available in 1964.

At the core of his work, Stehura explores the concept of idea generation, which for him meant the evolution of graphic visions. 'I wanted to see if I could create some semblance of a mind,' he explains. His landmark film, *Cibernetik 5.3*, is an abstract, graphic *tour de force*. It was made on a computer that didn't even have a screen – just punch cards and tape. In order to output the film he took his magnetic tapes from UCLA to General Dynamics in San Diego where there was a digital film recorder. He was only allowed one session on the computers there to realize his film. For Stehura, the excitement lay in not knowing what was going to come out of the machine: had he actually made a film or was it simply going to be unintelligible? Fortunately for Stehura, he had made an animation classic.

Stehura's experimental film was certainly well timed, coinciding as it did with the growing influence of LSD and psychedelia – he once ran it over three projectors at a Jimi Hendrix concert. For several years after he made *Cibernetik 5.3* Stehura worked on the implementation of a verbally controlled meta-system that could make the design of advanced computer animation systems an exceptionally simple process. He initially worked on mainframe computers, but in the mid-1970s he purchased a mini-computer that enabled him to use conventional animation techniques alongside advanced motion and transformational controls. However, Hollywood animation studios were not especially interested in new visual capabilities. According to Stehura, this part of his life was 'so labor intensive that it could have had dangerous health consequences'. He elaborates: 'I was relieved to change direction and immediately begin working on environmental and species restoration issues, which are vastly more crucial to our continuity and survival.'

Although Stehura made only one computer film, his contribution to the world of experimental computer animation should not be underestimated. He took it to a place it had never been before and where it is perhaps unlikely to venture again.

Cibernetik 5.3 (1960–65) is an abstract *tour de force* – colours and shapes swirl and bloom to create a truly psychedelic experience. This landmark film set a precedent for a new type of cinema that was interested in the wider themes of artificial intelligence and techniques and simulations to aid our understanding of the universe.

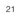

TITLE
Train Landscape

DIRECTOR
Jules Engel

COUNTRY OF ORIGIN
Hungary/USA

SOUND
Stan Levine

TECHNIQUE
Hand-drawn animation

FORMAT
16mm, colour

LENGTH
3 minutes

YEAR
1974

WEBSITE
www.iotacenter.org
www.julesengel.com

Jules Engel was born in Budapest, Hungary, in 1918 but has lived in Los Angeles since 1937. The variety of Engel's creative output is staggering: he is a celebrated animator in both experimental and commercial film, as well as a successful artist who works in a variety of media, including etching, sculpture, paintine and lithography.

In her forthcoming biography, *Jules Engel: Image in Motion, A Critical Biography*, Dr Janeann Dill describes Engel as 'a master artist and filmmaker whose abstract paintings and films have paved a visionary path for over six decades in experimental animation and the varied disciplines of fine arts (painting, printmaking, sculpture)'.

Engel commands form and structure in his films, and uses shapes and colour to communicate with his audiences. Unlike Oskar Fischinger, John Whitney Snr. and Larry Cuba, who all described their work as 'visual music', Engel prefers to use the definition 'art in motion'. 'Movement is action; our responses to it may be affected by our own state of mind as well as by the purely kinetic qualities of that motion. My work is abstract, but it contains an organic element that brings people close to their inner feelings', he explains.

Engel's best known commercial animation work has been for Walt Disney, and it includes the classics *Fantasia* (1940) and *Bambi* (1942). Engel designed the choreography for the Chinese and Russian dance sequences in *Fantasia*. After the Second World War he went on to become a founding member of United Productions of America (UPA) where he participated in the creation of the characters Gerald McBoing Boing and Mr. Magoo. In 1959 he formed Format Films with the late Buddy Getzler and Herb Klynn, where he produced *Icarus Montgolfier Wright* in 1962, for which he was nominated for an Academy Award.

Engel moved to Paris, France, in 1962 to direct the award-winning animated film, *The World of Sine*. While there, he made *Coaraze* (1965), which was, according to Dr Dill (in a conversation with Engel in 1998), premiered on Ingmar Bergman's invitation prior to a feature by Bergman himself. *Coaraze* won the Jean Vigo Award, the French equivalent of an Oscar, for Engel's direction.

When he returned to the US in 1969 Engel founded the Experimental Animation Department at the California Institute of the Arts (CalArts), where some of today's most influential animators were among his students, including John Lasseter and Christine Panushka, who said, 'Jules had a way of nurturing talent without imposing his aesthetics'.

Engel's work can be found in collections worldwide, including the Museum of Modern Art, New York, the Los Angeles County Museum of Art, the David Rockefeller Collection, New York, the Chicago Institute of Art and the Hirshorn Museum, Washington DC. He has completed over 33 personal films, many of which have received recognition from all over the world. His awards include the Norman McLaren Heritage Award from the National Film board of Canada and the Windsor McCay Life Time Achievement Award from the International Animated Film Society.

Train Landscape (1974) uses a multi-fold screen-print, 370 centimetres (145 inches) long, which features abstract shapes to create the effect of 'speeding' through a landscape.

TITLE
Sunstone

ANIMATOR
Ed Emshwiller

COUNTRY OF ORIGIN
USA

COMPUTER PROGRAMMER/ TECHNICAL SUPPORT
Alvy Ray Smith, Lance Williams, Garland Stern

PRODUCERS
Computer Graphics Laboratory, New York Institute of Technology

FUNDING
The Guggenheim Foundation

TECHNIQUE
Computer animation

FORMAT
16mm, colour

LENGTH
2 minutes, 57 seconds

YEAR
1979

WEBSITE
http://emsh.calarts.edu/ emshwiller.html

Born in 1925, Ed Emshwiller gained a degree in design from the University of Michigan, US, in 1949. He then studied graphics at the École des Beaux-Arts, Paris, and the Arts Student League, of New York. Many of the experimental films he made in the 1960s and early 1970s, such as *Relativity*, *Totem* and *Three Dancers*, received awards. Emshwiller went on to make extensive use of the Scanimate analogue video graphic system in his 1972 video projects, *Thermogenesis* and *Scape-mates*.

An Abstract Expressionist painter as well as an award-winning science-fiction illustrator, Emshwiller received a Guggenheim fellowship in 1978 and used his grant to explore the latest developments in digital computer graphics. He approached the New York Institute of Technology (NYIT) with a proposal to create a 30-minute computer graphic film project. Michael Scroggins, director of the computer animation labs at the California Institute of the Arts (CalArts), comments on this wild ambition: 'Years later he would fondly recount the story of how the team at NYIT (which included Ed Catmull, Alvy Ray Smith and other future founders of Pixar) laughed hysterically and told him he would be lucky to make a 30-second film since the newly developing medium was so resource intensive.'

Emshwiller rescaled his ideas, and the result was his innovative 3-minute, three-dimensional computer work, *Sunstone* (1979), one of the first painterly, digital computer graphics films. Most of the images in the film were digitally painted and made to move either by colour map cycling, by which shifting colours impart motion to otherwise static images, or by the more traditional frame-by-frame approach of creating a series of slightly different paintings that animate when played in sequence. At the end of the film the two-dimensional images are revealed as faces of an expanded cube rotating in three-dimensional space.

Scroggins explains the magnitude of this achievement: 'This was all accomplished at a time before there were any commercially viable 3D computer hardware and software systems. Jim Clark did not found Silicon Graphics until 1983 and the first digital video graphics system capable of 3D perspectives projection [the Ampex Digital Optics system] was not released until 1981.'

Emshwiller received numerous grants and awards throughout his career. He also taught at Yale University, the University of California at Berkeley and the State University of New York in Buffalo. He was dean of the School of Film and Video at CalArts from 1979 to 1990. Three years before his death in 1990 Emshwiller collaborated with the composer Morton Subotnick on a project called *Hungers*, an electronic video opera for the Los Angeles Arts Festival. *Hungers* used live performance and interactive devices that changed the sound of the music according to the environment. No two performances were ever the same. Emshwiller described this as getting film 'out of its can … the chaos theory, a slight deviation from the plan will take you into a whole new realm of possibilities'.

Sunstone (1979) features the 'sunstone', a face that appears to be carved from stone and from which a third eye appears. Brilliant transformations in textures and colours take place. As the film progresses, the 'sunstone' is revealed to be one side of an open, revolving cube, whose sides are made up of simultaneously moving images.

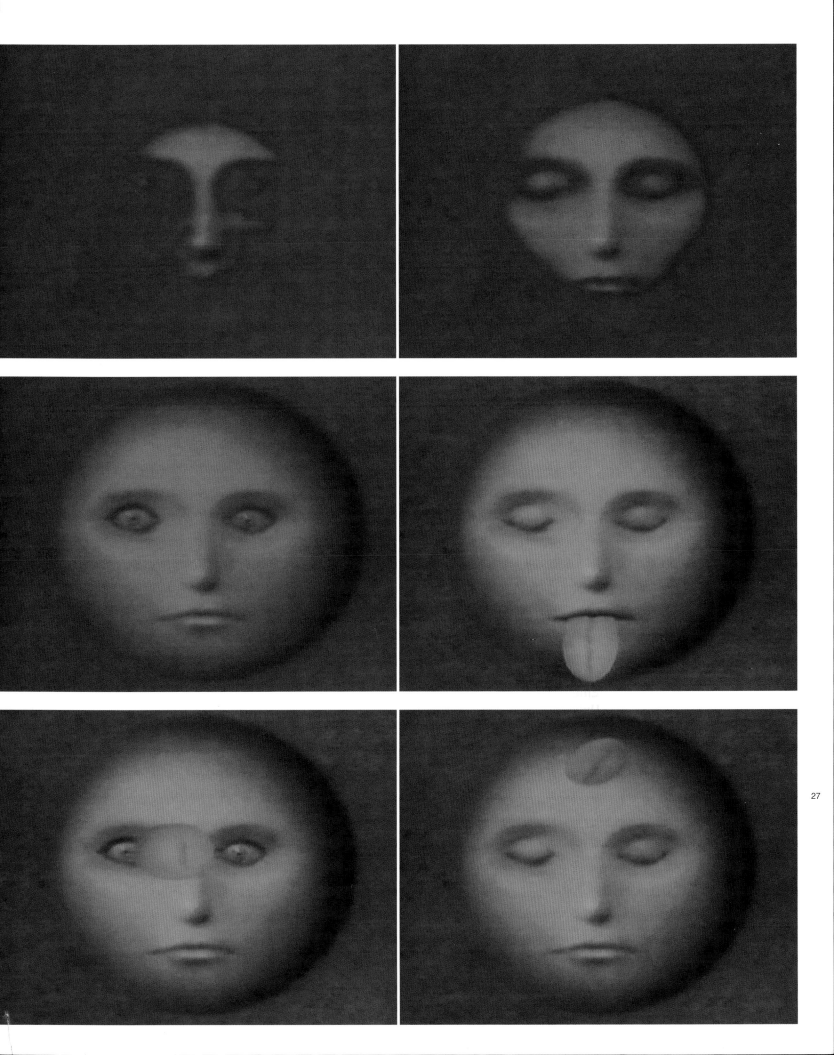

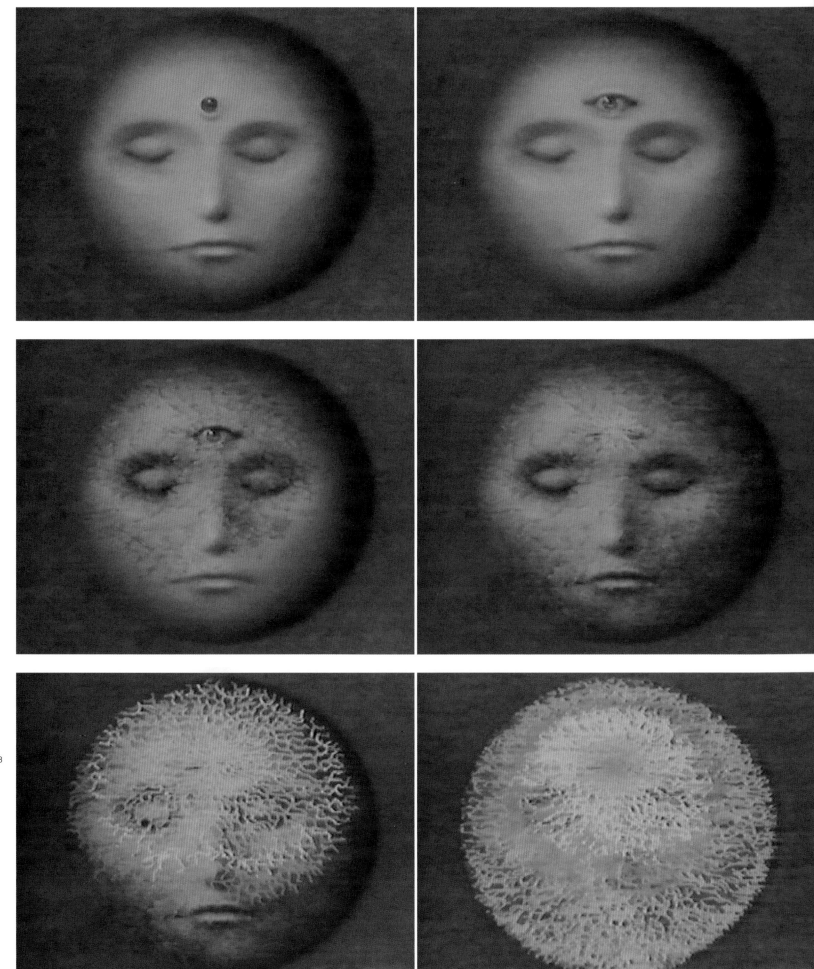

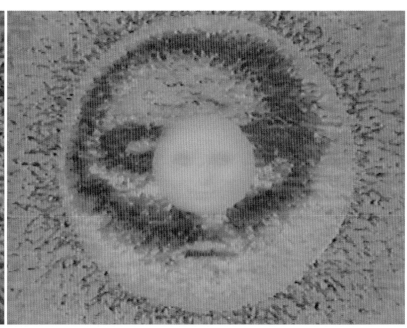

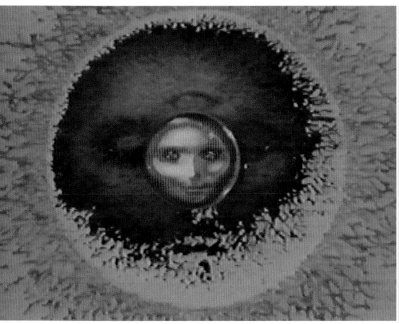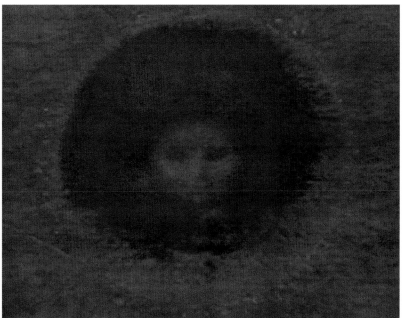

TITLE
Panspermia

SOFTWARE AND ANIMATION
Karl Sims

COUNTRY OF ORIGIN
USA

SOUND
David Atherton, David Grimes, Steve Blake, Target Productions

THANKS
Lew Tucker, Jim Salem, Carl Feynman, Dave Sheppard, David Marvit, JP Massar, Gary Oberbrunner, Danny Hillis

COMPUTER HARDWARE
Connection Machine CM-2

FORMAT
Digital

LENGTH
2 minutes, 8 seconds

YEAR
1990

WEBSITE
www.genarts.com/karl

Born in 1962 in Boston, US, Karl Sims grew up in Camden, Maine, and studied life sciences at Massachusetts Institute of Technology (MIT). 'While I was studying biology as an undergraduate, I had spent some time at the Visible Language Workshop and also the Architecture Machine Group where I was able to experiment with computer graphics and animation,' he says. Hence his decision to go on to study computer graphics at postgraduate level at the hugely influential Media Lab at MIT.

'Moving images can provide a very powerful experience and method for communicating information and ideas, but they usually require an extended effort to create,' says Sims. 'I was attracted to computer animation because I think it can help us more efficiently turn our visual imaginations into reality.'

Inspired by the writing of scientists such as Richard Dawkins, Sims's interest in science and technology is clearly reflected in his computer animations and interactive works. Indeed, he often himself wrote many of the software programs used to create his films: 'Some of my best work was done using specialized supercomputers where no graphics software was initially available,' he says. 'Of course, today there are many graphics and animation software packages available, and powerful computers cost a fraction of what they cost then.'

After graduating from MIT, Sims moved to California to join the production research team at Whitney/Demos Production. A few years later he was invited to work as artist-in-residence at Thinking Machines in Cambridge, Massachusetts, a position that gave him the freedom to begin his experiments. Careful never to allow either science or technology to overwhelm his subject matter, Sims uses a computer to create outcomes he himself would never have imagined: rather than designing worlds or landscapes, he uses the computer to 'grow' them. 'I'm inspired by nature, because of its seemingly effortless creation of beauty and complexity,' he explains.

Currently president of GenArts, the company he founded in 1996 to write special effects software tools, Sims continues to create his own animated experiments and films. *Genetic Images* (1993) allowed the interactive evolution of abstract still images and was part of an exhibition held at the Centre Georges Pompidou in Paris. His film *Particle Dreams* (1988) was created using three-dimensional particle systems techniques. His next film, *Panspermia* (1990), won the Golden Nica at the Ars Electronica festival in Austria in 1991. He also conducted experiments with populations of 'virtual block creatures' in *Evolved Virtual Creatures* (1994), where each is pitted against the other to find the strongest in various conditions. The most successful of the creatures survive and procreate, only for the process to start all over again: a compelling Darwinian experiment. Another interactive installation, *Galápagos* (1997), allowed visitors to 'evolve' three-dimensional animated forms. In 1998 Sims was awarded the MacArthur Fellowship for 'extraordinary originality and dedication in creative pursuits', and he continues relentlessly to explore and experiment with technology.

Panspermia (1990) features an alternative universe, which Sims created through computer technology. It contains its own orbit and planetary plant life activity in what is described as a 'self-propagating system'. The title itself is the name for the particular concept about life forms that is featured in the film.

TITLE
Eggy

DIRECTOR
Yoichiro Kawaguchi

COUNTRY OF ORIGIN
Japan

COOPERATION
Nippon Electronics College,
NVS association

STAFF
Shinji Sasada, Kuzo Chiba,
Kazuyuki Tanabe

TECHNIQUE
Computer animation

FORMAT
HDTV (High Definition images)

LENGTH
4 minutes

YEAR
1991

Born on Tanegashima Island, Japan, in 1952, Yoichiro Kawaguchi gained a degree in visual communication design from the Kyushu Institute of Design in 1976. He went on to receive a masters degree from Tokyo University of Education and made his first computer images in 1975. Since 1986 he has been involved in research work in the field of High Definition TV (HDTV).

Kawaguchi's work straddles the worlds of computer imaging, evolution, genetics, mathematics, art and animation. Although he is a filmmaker and has won many awards for computer animation, he is by no means a traditional animator; his eye-popping films generate themselves by means of a computer program he created himself. This unique method of artistic experimentation and the output it generates ensure that Kawaguchi's films stand out from the crowd. The program, which is called Growth Model, is a computer model based on growth algorithms. Using it, he creates virtual living worlds, and his dazzling animated films are the products of this experimentation.

In Kawaguchi's cyberspace colours are bright and metallic, and the objects (or creatures) that populate the films are organic: sometimes smooth, others are angular and complex. He comments: 'When we create the ecological artificial creatures in cyberspace, they need an attractive place to live while self-increasing. This place is also self-generating like a re-generated neuron network.' Once he has programmed the parameters of a virtual world, the virtual creatures begin life as we do – as a simple cluster of cells. Then the self-organizing begins and new creatures are born, who repeat the generating and dying while interacting with each other to produce new creatures. Films featuring this project include *Tendril* (1982) and *Ocean* (1986).

Kawaguchi also researches into forms of 'intelligent art'. The virtual living worlds he creates evolve and die, and he believes that if truly intelligent art is to be a future reality it will need to be embued with human intelligence. He would like to add this element to his Growth Model.

His current work and research, as a professor at the Centre for Advanced Science and Technology in the University of Tokyo, is allowing him to explore such possibilities. Since 2000 he has been working on a project entitled *Gemotion, Growth, Gene + Emotion*. His research aims to determine what meaning a three-dimensional, reacting-image screen would have as new art. He is also exploring the reactions of art to touch and emotion, arguing that once art can react to humankind, we will embark on a new journey in our relationship with it. He writes: 'We never experience art unless we make something in practice.'

This exploration of organic art and growth has been and is Kawaguchi's lifelong work. In 1983 a review in *Computer Graphics* magazine, read: 'Kawaguchi's growth algorithms perfectly blend aesthetic design and sophisticated computer science to produce a distinct organic effect. Kawaguchi is one of the pioneers of these techniques and is apparently their undisputed master.

In 1991 **Eggy** was awarded a distinction for computer animation by the Prix Ars Electronica. The film was made by HDTV, and its organic abstract visuals typify Kawaguchi's work.

ERICA RUSSELL

TITLE
Triangle

DIRECTOR
Erica Russell

COUNTRY OF ORIGIN
New Zealand

TECHNIQUE
Cel animation

FORMAT
35mm, colour

LENGTH
8 minutes

YEAR
1994

Erica Russell was born in New Zealand to artist parents and grew up in South Africa. She moved to London in 1972 and began her career in animation although she had had no formal training. In fact, when she was a child there was no television in her family home and she had never seen any animated films. Quite by chance, her first job in London was in the studio of three-time Oscar-winning animator, Richard Williams, where she worked on 'the lowest job' – paint and trace work.

Staff at Williams's studio were encouraged to use the facilities to develop their own talent and each morning they would gather to watch film rushes from the previous day. Personal work processed by the studio was also shown, and this was how Russell got her break as a filmmaker.

Disney animator Art Babbitt saw some of Russell's drawings and promptly asked her to assist him on a project for six weeks, thereby helping her to skip several layers of office hierarchy. Russell then went on to work with illustrator and animator, Gerald Scarfe (probably best known for his political caricatures). She continued assisting before turning freelance in the early 1980s. During her freelance years, Russell often worked for Cucumber Studios, where she produced the titles for the cult youth programme *The Tube*, and directed numerous pop promos.

Having taken time out to raise a family, Russell soon decided to concentrate on her own films and established her first production company, Eyeworks. 'The intention was to make commercials and use the cash to feedback into my short films,' she explains. Eyeworks produced a high-profile campaign for the launch of Virgin Megastores, while Russell herself worked on the pilot for her first film, *Feet of Song* (1988). When the commissioning editor for animation at Channel 4 agreed to provide the finance for *Feet of Song*, Russell dropped commercial work altogether in order to focus on making the film. Channel 4 then went on to commission Russell's most successful film to date, *Triangle* (1994), which led her to close Eyeworks and set up a studio in her home.

Russell does not produce storyboards or use narratives. In *Triangle* she opted to tell the archetypal story of an eternal triangle of love, hate and jealousy so that 'the order that they come in is arbitrary'. *Triangle* took 16 months to make and earned Russell an Oscar nomination for Best Animated Short Film in 1995. This success ensured a third commission from Channel 4 for a film called *Soma* (1999).

Soma came as a 'bit of a shock' for Russell's fans and was actually rejected by many of the festivals that had previously invited Russell to submit her work. Based on the work of US artist Jean-Michel Basquiat, *Soma* is raw and urban compared with the slick and choreographed *Triangle*. Russell, however, was happy with her film: 'You never want to repeat yourself – that's what commercial artists do. Animation is so repetitive that it becomes deathly boring if you do that – *Soma* has some of the best animation I have ever done.' Meanwhile, she is currently working on taking her animation out of television and into an installation space.

Triangle (1994) starts with the simple drawing of a triangle, used as a symbol to depict innocence before sophistication. The film sees a man and two women dancing through sequences and playing out emotions, such as innocent love, playfulness, intrusion and persecution. *Triangle* successfully combines form and abstraction with dance and music.

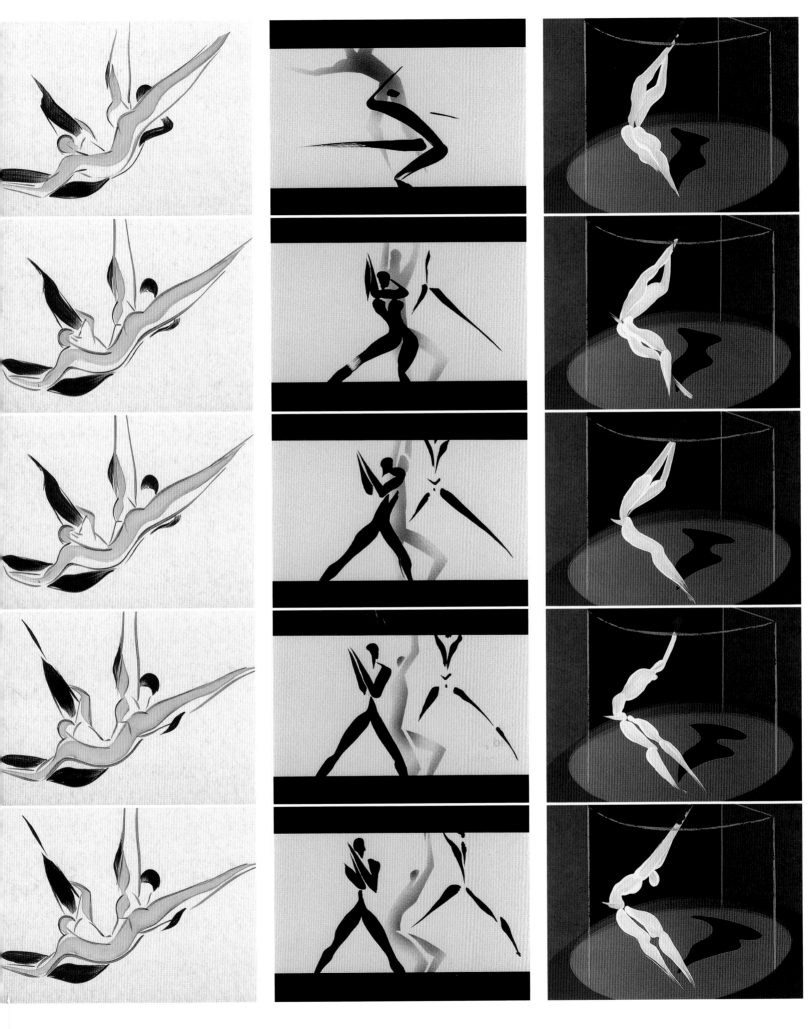

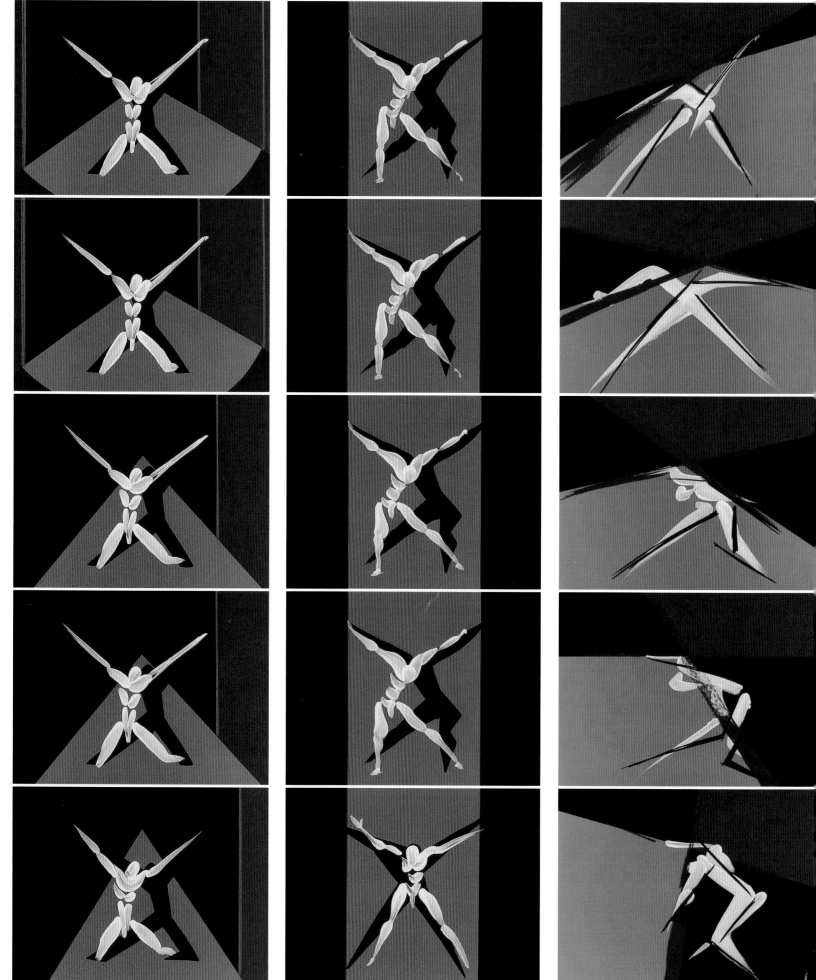

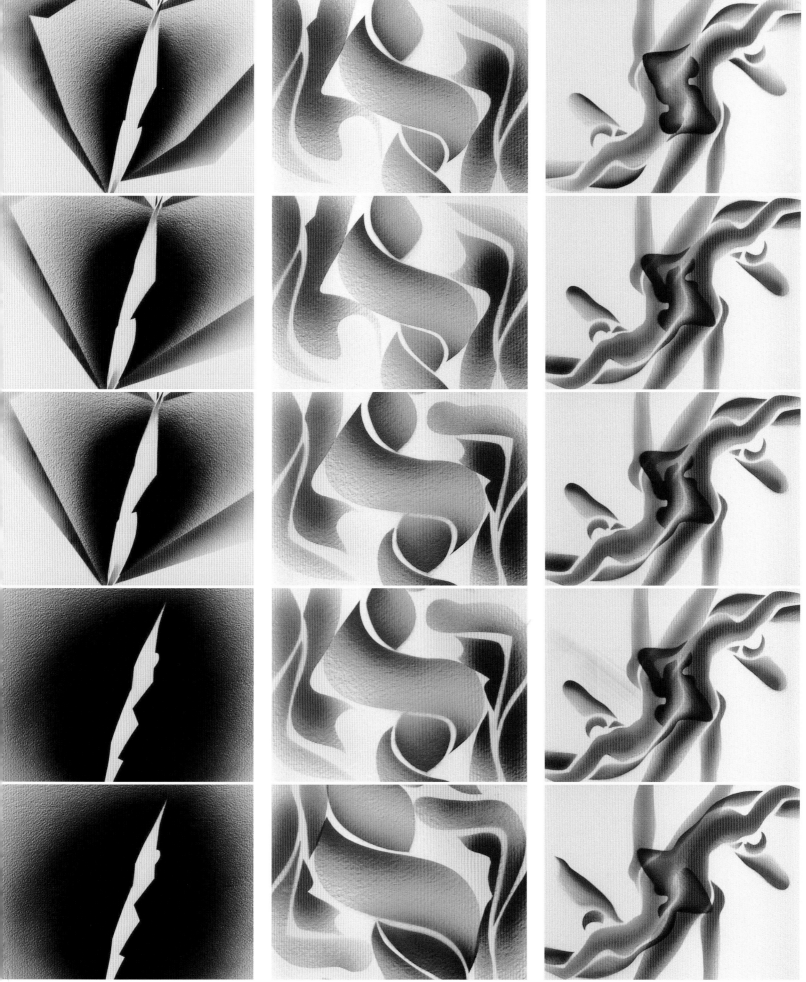

TITLE
'Aug 16th

ANIMATION AND PROGRAMMING
James Paterson and Amit Pitaru

COUNTRY OF ORIGIN
USA/Canada

MUSIC
Just Plain Scared by The Big Lazy (Stephen Ulrich, Paul Dugan, Tamir Muskat)

TECHNIQUE
Software, ink on paper, sound

FORMAT
Digital

LENGTH
2 minutes, 43 seconds

YEAR
2001

WEBSITE
www.insertsilence.com

Insertsilence is an experimental collective that was formed in 2001 by James Paterson and Amit Pitaru. Born in Israel in 1974, Pitaru was taught composition and piano by the modern composer, Arik Shapira. Having signed a major record deal, he moved to live in New York in 1997, which was when he first met British-born designer, James Paterson. Paterson had studied drawing and printmaking in Toronto and Halifax in Canada but had given up studying for a bachelor of fine arts degree in order to work in New York as an interface designer. Insertsilence was a vehicle that enabled them to work together on a variety of innovative and abstract projects. 'More concretely, Insertsilence is a website, an artists' collective, a production team, and a friendship,' says Paterson proudly.

'I wanted to extend my experience as a musician towards visual motion and composition,' says Pitaru of his initial interest in animation. Paterson, meanwhile, says of his own work: 'All of my drawing was focused on movement and dynamics before I ever animated, so it was a natural and comfortable step forward for me.'

Having begun their experiments with Flash 2, they now use 'a collection' of software and programming languages to create their animations, while much of their work also consists of hand-drawn images to give a beautiful, organic feel. 'Ahead of time we prepare the software tools and the hand-drawn source material,' Pitaru explains. 'Then we use the tools to manipulate the hand-drawn material in a music-like, improvisational manner.' Many of their films have won international prizes – *'Aug 16th*, for example, was given the 'motion graphics' award from the Flash Film Festival in 2001.

The pair do not limit themselves to personal projects, but also work on commercial commissions for clients such as Björk, PlayStation 2, Diesel and Mick Jagger of the Rolling Stones. But personal work remains a passion and includes solo projects such as www.pitaru.com, www.presstube.com and www.halfempty.com.

Paterson and Pitaru are respected names in the field of new media design, and their work has been exhibited in galleries from Seoul and Brooklyn to London. They remain passionate about the potential of the Internet, not just as an interesting medium for design but also because it offers a way to help solve the problem of a lack of viewing opportunities for short films, animated or not. 'More artists should put their work on the Internet', comments Paterson. 'Then it would be available all the time, and prone to wider distribution.'

'**Aug 16th** (2001) is a manifestation of our desire to play animation as if it were music,' explains James Paterson, one half of the creative partnership Insertsilence. Their starting point was hand-drawn artwork, which was then processed and scanned into custom-built software, which allowed the pair to 'perform' and then record the animation.

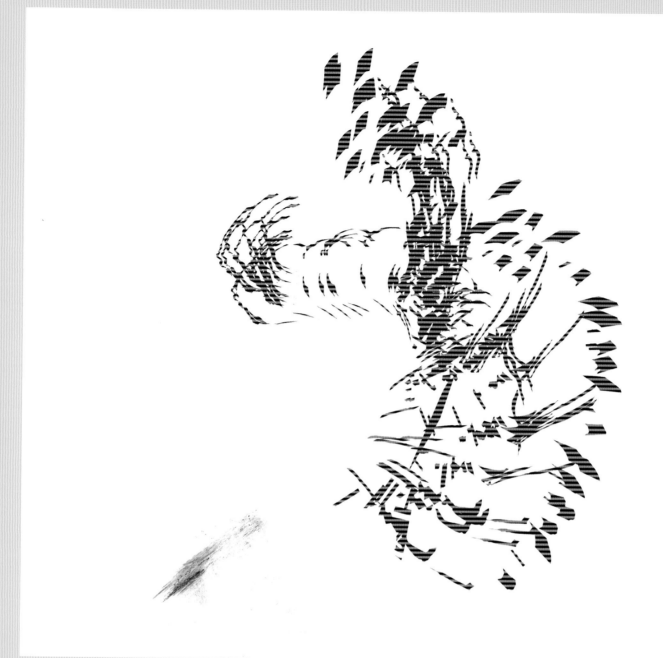

TITLE
Full Moon

ANIMATION, DIRECTION, SOUND DESIGN AND EDITING
Paul Glabicki

COUNTRY OF ORIGIN
USA

TECHNIQUE
Lightwave 3D Software and digital video compositing

FORMAT
VHS, Betacam SP, DVD, colour

LENGTH
42 minutes

YEAR
2001

WEBSITE
www.pitt.edu/~studio

Animation has always been a passion for American animator Paul Glabicki, who devoured all things Disney while he was young. Encouraged by his parents, he even wrote to the Studio, asking technical questions about colour, composition and character, and he also used to experiment himself, making flip-books.

Born in 1951, Glabicki received a bachelor of fine arts degree in painting at Carnegie-Mellon University, Pittsburgh (1972) and two masters degrees as a graduate at Ohio University, for painting (1974) and film (1979). It was during the 1960s that Glabicki borrowed a Super-8 camera and began to make his own animated films. *Windows* (1968) was made using clippings taken from magazines such as *Time* and *Newsweek* and was a collage of iconic images, such as the moon landing or the war in Vietnam, all filtered through a coloured lens.

Most of his early animated films were created from thousands of images, painstakingly drawn by hand on paper. In fact, these images are so breathtakingly intricate that they could almost be mistaken for computer animation. Two of these films, *Film-Wipe-Film* (1983), for which he drew the same circle thousands of times, and *Under the Sea* (1989), which is an abstract adaptation of fragments of five classic novels, each took four years to make.

His first forays into computer animation, made between 1990 and 1992, were motion studies entitled *Computer Animation Studies*, which were exhibited in galleries using multiple video monitors in large spaces. From 1992 to 1996 his work evolved into computer-generated artificial environments intended for three-dimensional stereo projection. This work began with *Memory Spaces (1993–96)*, an ongoing project in which complex environments were digitally constructed from memories of places Glabicki had visited around the world.

'I love computer animation but I do get impatient with the ongoing obsession with photo-realism,' he says. 'I often deliberately subvert realism by creating spaces and spatial relationships that are impossible. I often apply highly abstract organization to my computer animation, while manipulating image fragments or recognizable objects. As an artist living in this point in history, I feel compelled to explore new media, shape it to my vision and make it my own.'

Certainly, Glabicki's work covers a wide range of different artistic disciplines, including painting, drawing, filmmaking, photography, installation art, video art, sound and electronic media. It is perhaps this breadth and scope that have led to his gaining critical acclaim from the art world (unusual for animators). He was awarded a fellowship from the Guggenheim Foundation in 1986 and was named Artist of the Year by the Pittsburgh Center for the Arts in 2001. He has also chaired the Studio Arts Department at the University of Pittsburgh, where he has taught since 1976.

Full Moon (2001) was originally designed for continuous single or multiple monitor display (as well as video projection) in a gallery space. Comprising an imaginary universe of art, nature, beauty, poetry and science, at 42 minutes it's not exactly what you might call a short film, but it is a stunning study of objects and images in choreographed harmony.

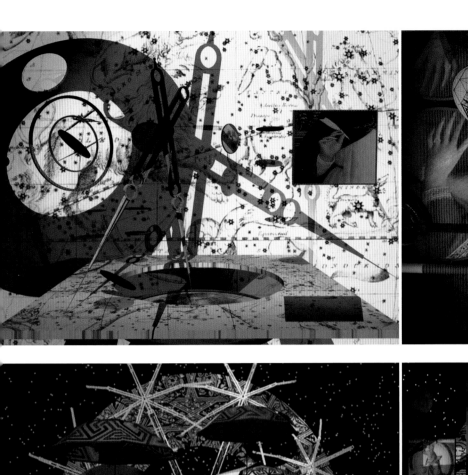
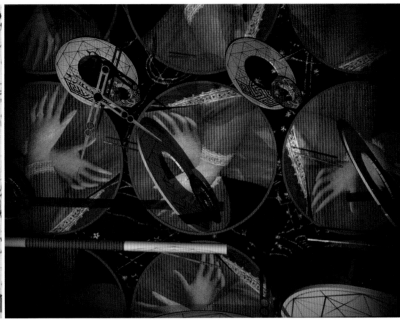

Perhaps unsurprisingly, music often plays a very important role in animation, where image and sound come together to produce a unique art form. This chapter presents films in which the soundtrack has been a determining factor, in a relationship that is predominantly experimental. Norman McLaren's *Synchromy* (1971) is one such example, where the visuals were also printed in the soundtrack section of the filmstock, so that the sound is a direct equivalent of the images. Stan VanDerBeek collaborated with Bell Telephone Laboratories to create theatrical multimedia pieces, culminating in his construction of a Movie Drome in New York in which he projected his audiovisual extravaganzas. *Breathdeath* (1964) is an example of his work.

Directors regularly use sound as their starting point. Mary Ellen Bute studied the possibilities of synchronizing light and sound under the Russian musician Lev Theremin (the inventor of the musical instrument of the same name). In her film *Spook Sport* (1939) the characters move in time to music by Saint-Saëns. London-

SOUND

based director Alexander Rutterford based his film, *Monocodes* (2000), around synthesized sounds, the visuals being abstract representations of those noises. Meanwhile, Dutch interactive artist Han Hoogerbrugge has commented simply that in films such as *Flow* (2001) music is 'the glue that keeps the images together', and UK artist Tim Hope forced himself to shoot and reshoot his short film, *The Wolfman* (1999), so that the visuals would live up to the promise of the audio. 'I laid out the piece of sound before I even started on any animation,' he explains. 'If you listen to the sound and that works then almost invariably the animation will work fine on top of it.'

Many animation directors also compose the music for their films themselves, includin
Japanese director Tomioka Satoshi, whose film *Sink* (1999) is featured here, and
French collective Pleix, whose members individually work on creating both animation

and music, as shown in *Bleip: No* (2001). French director Jean-Luc Chansay was himself signed as a musician to EMI, and though he now works by day as a web designer, he regularly makes films to accompany music by his favourite artists. He considers that these personal works, made only to satisfy himself, are among his best work. Electronic act Plaid, the band which wrote the track *Eyen*, for which Chansay animated a film in 2001, agreed with him and released the track and video on a later EP.

Other filmmakers have worked on promos for various music artists. The Quay brothers' commercial work includes Michael Penn's *His Name is Alive* and the celebrated Peter Gabriel promo, *Sledgehammer*, created with Aardman Animation. Their collaboration with avant-garde composer Karlheinz Stockhausen resulted in the beautiful short film *In Absentia* (2000). Dylan Kendle has shot promos for music groups Underworld and Add N to (X), but in his short film *Third Interpolation* (1999) he combines the music of Edgar Varèse with abstract, geometric forms. 'Varèse scored a piece of concrete music for the Philips pavilion at the 1958 Brussels World Fair,' Kendle explains. 'The structure was designed by Le Corbusier and the piece played over 400 speakers within it. Having seen no photos of the pavilion I could only imagine the unwitting audience's reaction as it stumbled into the brutal space. With this film I wanted to create an abstract environment that played with space and scale in a way that echoed the dynamic of his music.'

Other diverse approaches to the use of sound include its deliberate absence, which can also have great impact on the viewer's experience. See for example, Oskar Fischinger's *Radio Dynamics* (1942), where a deliberate silence leaves the audience to concentrate on the film's 'inner dialogue'. Larry Cuba's work, in contrast, creates films where the images are totally in harmony with the musical accompaniment. Cuba's *Calculated Movements* (1985) explores the direct connection between algebra, music and abstract form.

TITLE
Spook Sport

DIRECTOR
Mary Ellen Bute

COUNTRY OF ORIGIN
USA

ANIMATION
Norman McLaren

PRODUCER
Ted Nemeth Studios

MUSIC
Danse Macabre by Saint-Saëns

TECHNIQUE
Cel animation and McLaren's drawn-on-film effects

FORMAT
35mm, colour

LENGTH
8 minutes

YEAR
1939

Born in Texas, US, in 1906, Mary Ellen Bute was a pioneer in experimental animation. She left home when she was 16 years old to attend Pennsylvania Academy of Fine Arts, where she studied painting. She became fascinated by modern art, especially the abstract painters, such as Paul Klee, Georges Braque and Wassily Kandinsky, and began her lifelong passion with light, movement and form.

Bute did not immediately become interested in filmmaking, however. Indeed, she once remarked that she found it 'too commercial'. Instead, she worked in the theatre, entering the Inter-Theater Art School, New York, in 1924 and working on lighting productions. She enrolled as a student in Yale University's new drama department to pursue this further.

After leaving Yale she joined the Floating University as director for its theatre, which gave her the opportunity to travel around the world, visiting 33 countries, including India and Japan. She then studied history of art at the Sorbonne, Paris, where she became convinced that 'a kinetic art form of colour is to be the contribution of our age to the history of art'.

Returning to New York in 1929, she assisted the electronic inventor Thomas Wilfred, who was developing a 'colour organ' or clavilux, which enabled him to paint with light. She then became apprentice to the Russian-born musician Lev Theremin, who had invented an electrophonic instrument, an aetherophone, which produced notes from movements in the air. Bute worked with Theremin on a paper entitled 'Light and Sound and their Possible Synchronization', which they presented in 1932. She also collaborated with the painter and mathematician Joseph Schillinger, from whom she learned how to plan the movement of abstract forms using a mathematical system that he had invented for the teaching of music.

In 1934 Bute met the cinematographer Ted Nemeth, whom she married in 1940 and with whom she established a small studio. Their first film together, made with Melville Webber, was *Rhythm in Light* (1934). By 1950 Bute had made nine animated shorts, including *Synchromy No. 2* (1935), *Parabola* (1937), *Spook Sport* (1939), made in collaboration with Norman McLaren, *Escape* (also known as *Synchromy No. 4*, 1937), *Tarantella* (1940) and *Polka Graph* (1947).

During the 1950s Bute's work developed further as she began to create films by using oscilloscope patterns to create the main 'figures'. The oscilloscope, which translates electronic impulses into visual patterns in motion, gave her an entire repertoire of light forms and she made two films, *Abstronic* (1952) and *Mood Contrasts* (1953), with this technology.

In 1956 she produced a short, *The Boy who Saw Through*, and spent the next decade working on a live-action feature based on James Joyce's *Finnegans Wake*, for which she won first prize at the Cannes Film Festival in 1965. She died in 1983, leaving unfinished a docudrama on the poet Walt Whitman.

To make **Spook Sport** (1939) Mary Ellen Bute worked with Norman McLaren, who drew the 'characters' of the ghosts and spectres directly on the filmstock. The movements of the figures were synchronized with music from Camille Saint-Saëns' symphonic poem, *Danse Macabre*.

TITLE
Radio Dynamics

ANIMATION, DIRECTION AND DESIGN
Oskar Fischinger

COUNTRY OF ORIGIN
USA

MUSIC
None

TECHNIQUE
Animated cels on nitrate stock

FORMAT
35mm, colour

LENGTH
4 minutes

YEAR
1942

WEBSITES
www.iotacenter.org/
fischinger/index.htm
www.oskarfischinger.org

OSKAR FISCHINGER

Described in the *New York Times* as 'cinema's Kandinsky', Oskar Fischinger was a pioneer of abstract filmmaking. Born in the German village of Gelnhausen in 1900, he trained as an architect and engineer in Frankfurt before embarking on a career in avant-garde cinema.

As early as 1920 Fischinger began to explore cinematic techniques in painting, and by 1922 he had started to make abstract films by synchronizing images to popular music of the time. His goal was to create a purely abstract type of art based entirely on motion. He produced a series of films set to musical recordings called *Studies*, each of which ran for 3 minutes and included around 5,000 drawings. The *Studies* were screened in cinemas and promoted the recordings, making them, in effect, the world's first pop promos. In each of the films shapes drawn from everyday phenomena dance and flow in a seamless, organic fashion.

By the early 1930s Fischinger was running his own production company in Berlin where he produced title sequences, special effects for movies and advertisements, winning international recognition for the experimental animations he made in his spare time. However, after Hitler's rise to power, his work in experimental cinema was regarded as 'decadent art' by the Nazi regime. Fischinger was fortunate enough to receive an invitation from Paramount Pictures to make some short films and so he left Germany for Hollywood.

His move to the US was the start of an exasperating struggle for Fischinger. An artist who wanted to make abstract films, he found himself working in an industry that was hostile to non-representational art. As his biographer Dr William Moritz comments: 'Fischinger's films have universal appeal, in part because of his deeply ingrained spiritual feeling for the sacredness of the abstract geometrical shape.' This spiritual feeling was not shared by the Hollywood studios, and Fischinger soon left Paramount to join MGM, where he made *An Optical Poem* (1937). He went on to the Walt Disney Studio, where he worked for a short while on the Toccata and Fugue section of *Fantasia*, leaving after just nine months. A letter to a friend outlines his frustration with the Hollywood machine: 'The film is really not my work … Rather it is the most inartistic product of a factory.'

Orson Welles admired Fischinger's work and hired him to work on a Mercury Productions feature about the jazz scene in the early 1940s, and he kept on paying him even after the project had fallen through. Using his own resources Fischinger made two films in the 1940s, *Radio Dynamics* (1942) and his last film, *Motion Painting No.1 (1947)*, which won the Grand Prix at the 1949 Brussels Experimental Film Competition. There was no prize money or distribution for the film. A disillusioned Fischinger abandoned experimental filmmaking and turned to painting for the remaining years of his life. He died in 1967.

Radio Dynamics was created in 1942 and was started as a collaboration with Orson Welles. The film was originally set to music, but when the project fell through Fischinger turned it into a silent piece. It is a stunning visual evocation of inner dialogue and meditation. It was animated on paper, as was most of his work, and made without cels or camera movements.

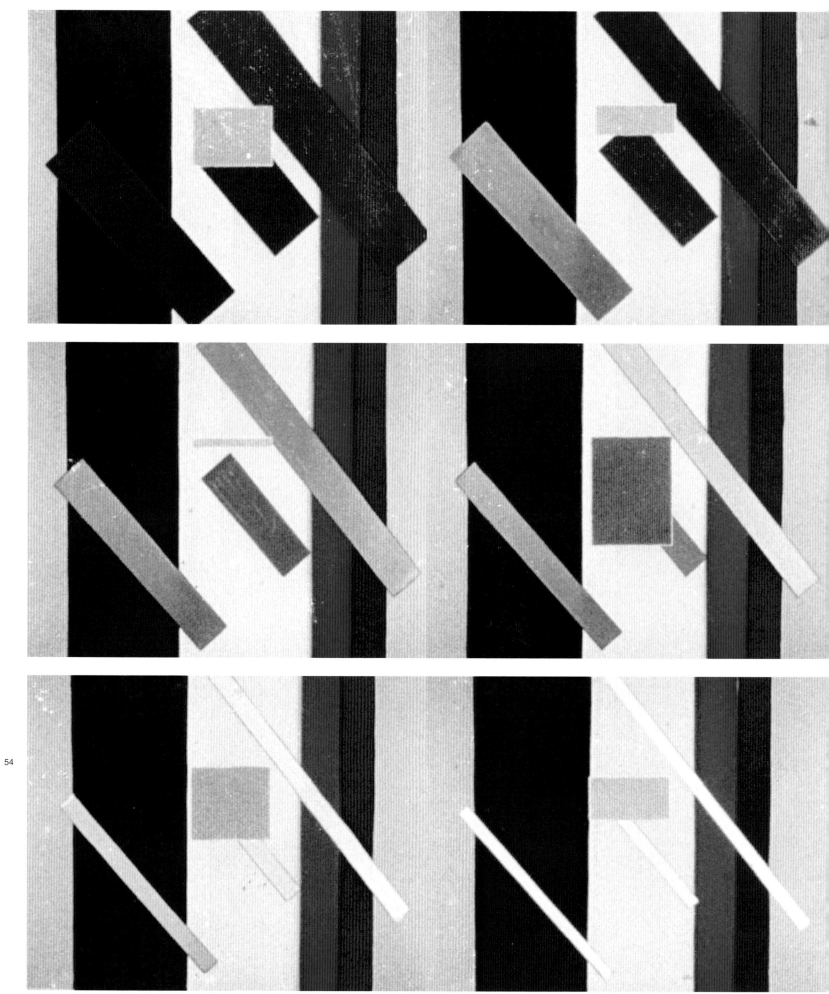

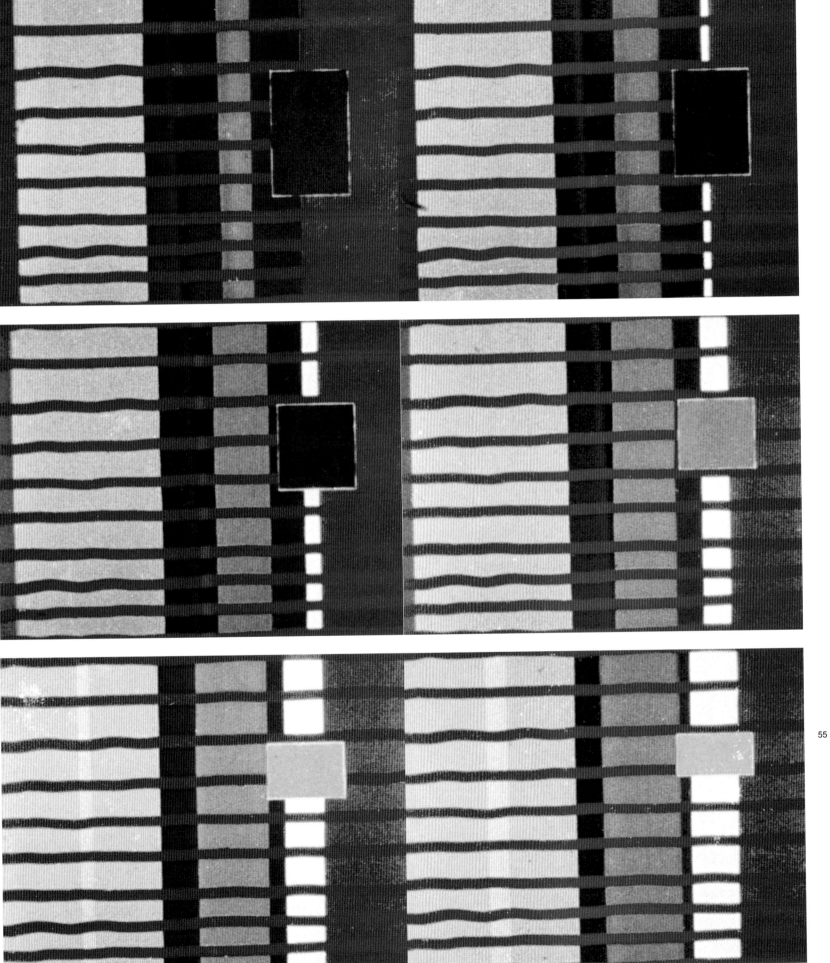

TITLE
Breathdeath

DIRECTOR
Stan VanDerBeek

COUNTRY OF ORIGIN
USA

TECHNIQUE
Collage

FORMAT
16mm, colour

LENGTH
13 minutes

YEAR
1964

STAN VANDERBEEK

Stan VanDerBeek was born in New York, US, in 1927 to Dutch and Danish immigrants. He studied art and architecture, first at Cooper Union College, New York (where he was awarded an honorary doctorate in 1972) and then at Black Mountain College, North Carolina.

VanDerBeek was a pioneering experimental animator and filmmaker who used a wide variety of materials and technologies. His life's work was an ongoing search for new methods and materials. During his lifetime he achieved widespread recognition in American avant-garde cinema, and he was also an early advocate of interactive television.

During the mid-1950s VanDerBeek worked on a children's television show called *Winky Dink and You*. The *Winky Dink* show had a slot in which children were asked to place a sheet of clear plastic – called 'magic screens' – over the television screen and draw their own objects on to animated scenes. After the shows, VanDerBeek would use the animation screen to create his own works. These surreal collages are widely cited as an inspiration for *Monty Python* animation director Terry Gilliam.

VanDerBeek began making films in 1955, and in the course of his career he made a wide variety of films in a range of styles, including comedies based on the Cold War, such as *Achoo Mr. Kerroochev* (1960) and *Breathdeath* (1964). He also experimented with other techniques, such as superimposition.

In the early 1960s he and his wife, Johanna, moved to an artists' colony near New York, and it was here that VanDerBeek built his famous Movie-Drome inside a grain silo, where audiences could lie down and view multiple projections of films, images and animations. His desire to explore computer animation led him to work with computer graphics innovator Ken Knowlton as an artist-in-residence at the Bell Telephone Company Laboratories. There he produced dozens of experimental computer animations, which served as precursors of modern digital design. In addition to his filmmaking, VanDerBeek travelled and taught all over the world.

Among his numerous awards were grants from the Rockefeller Foundation, the Guggenheim Foundation, the Ford Foundation and the National Endowment for the Arts, as well as an American Film Institute Independent Filmmaker Award. He was artist-in-residence at public television station WGBH in Boston and at the University of South Florida, and professor of art at the University of Maryland, Baltimore. His work has been the subject of retrospectives at the Museum of Modern Art and the Whitney Museum of American Art, both in New York.

He died in 1984 at the relatively young age of 57 of kidney cancer. His obituary in *Film Comment* (Jan/Feb 1985), written by Amos Vogel, read: 'His achievements lie less in the individual works than in the staggering totality of his entire endeavour: a restless, passionate search for new techniques, new media and new concatenations. De-bunker, premature "de-constructionist" and smiling deadly serious anarchist, he moved from flip-books, to cut-outs to live animation, from collage, holograms, and Polaroid constructions to computer graphics and video, mixed-media and multiple screens.'

An early experimental computer animation, **Breathdeath** (1964) is dedicated to Charlie Chaplin and Buster Keaton. The film is a collage-animation, made from photos and newsreel that were taken apart and put back together again in a surreal way.

TITLE
Synchromy

DIRECTION, ANIMATION, PRODUCTION
AND MUSIC
Norman McLaren

COUNTRY OF ORIGIN
USA/Canada

PRODUCTION
© 1971 National Film Board
of Canada

EXECUTIVE PRODUCER
Robert Verrall

SOUND
Roger Lamoureux

IMAGES
Ron Moore

TECHNIQUE
Sound striations transferred
optically from track to picture
area

FORMAT
35mm, 16mm, Betacam SP,
colour

LENGTH
7 minutes, 27 seconds

YEAR
1971

Born in Stirling, Scotland, in 1914, Norman McLaren studied design at the Glasgow School of Fine Arts in 1932 and soon began experimenting with film. As a member of the Glasgow Film Society, he soon became familiar with the works of filmmakers such as Oskar Fischinger. Seizing on film as a vehicle of expression, he began painting directly on to film and scratching the emulsion to let light in. He was unaware of Len Lye's similar experiments in New Zealand at the same time.

McLaren officially began his career as a filmmaker in 1934, and in 1935 two of his films won prizes at the Scottish Amateur Film Festival, where John Grierson, a fellow Scot, was a judge. This early encounter with Grierson was pivotal to both McLaren's career and to the future of animation. Grierson, who was head of the General Post Office (GPO) Film Unit, spotted the young McLaren's talent and promptly offered him a job. In the early 1930s, the GPO had started to produce experimental films, including Len Lye's *Colour Box* (1935) and *Rainbow Dance* (1936). McLaren's *Love on a Wing* (1938) was a demonstration of his own animation techniques.

In 1939, fearing war in Europe (he had served as a cameraman in the Spanish Civil War), McLaren emigrated to New York, where he became an independent filmmaker. Meanwhile, Grierson had been appointed the first film commissioner of the National Film Board (NFB) of Canada. In 1941 Grierson contacted McLaren and offered him the chance to establish an animation studio and to train the first generation of Canadian animators, an opportunity he took.

McLaren spoke in 1959 about how music and sound greatly affected his work: 'An artist may be like a person who hears music and just starts to dance. He may be dancing for his own satisfaction, but what motivates him to dance, also motivates hundreds of other people to dance. The artist is only speaking some kind of common language, speaking it to himself, expressing something; and yet, other people come along and recognize it and realize that in this person's dancing, there is something new and different.'

During the Second World War McLaren made many public-service films, including *V for Victory* (1941), *Five for Four* (1942), *Dollar Dance* (1943) and *Keep Your Mouth Shut* (1944). Afterwards, he returned to making short films. His films have won more than 200 international awards to date. *Neighbours* won an Oscar in 1952, and *Blinkity Blank* received the Palme d'Or for short films at the 1955 Cannes Film Festival.

With the exception of two brief stints in China and India for UNESCO, McLaren remained with the NFB until his retirement. Years after his death in 1987, his reputation and influence are as strong as ever. He was described by the editor of the Québec magazine *Séquences* as the 'poet of animation'. His life's work of more than 50 films explored the relationship between colour, sound and music rather than narrative.

Synchromy (1971) allows the viewer to 'see' music – the film's images generate the sound. McLaren achieved this by creating a set of cards with different patterns of stripes, which, when reduced into the soundtrack area of the filmstrip, corresponded to different notes in the scale. The colour was added in the printing.

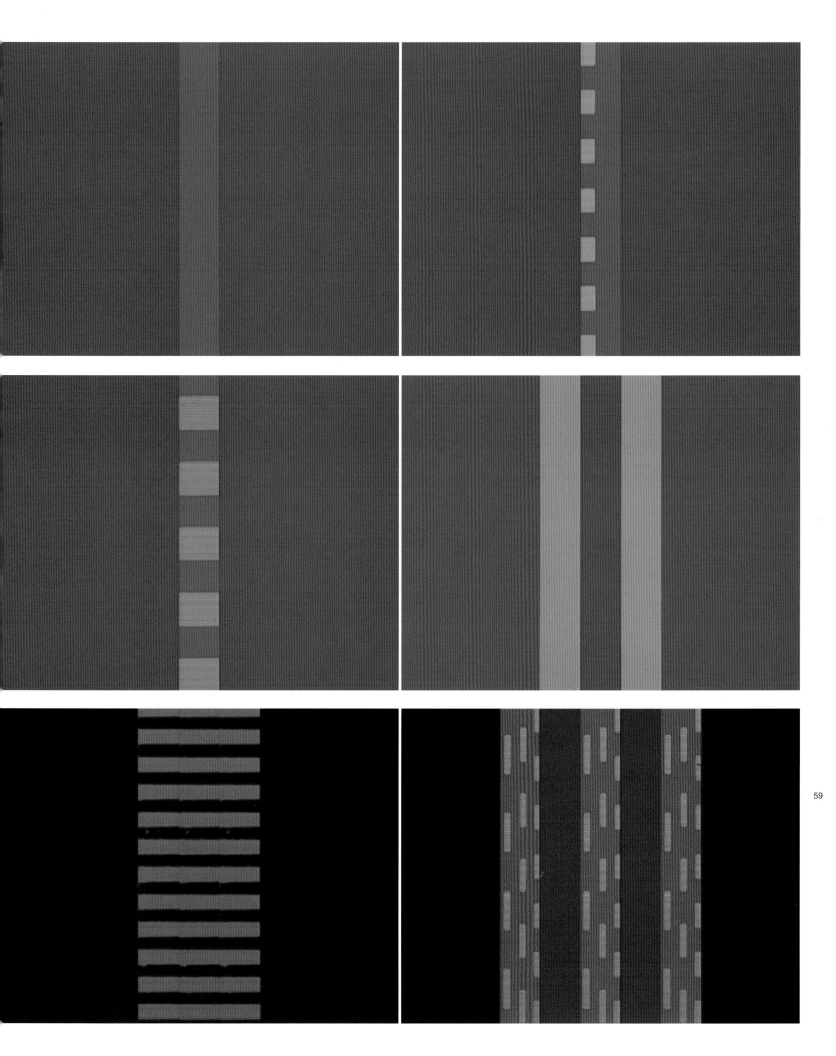

LARRY CUBA

TITLE
Calculated Movements

DIRECTOR
Larry Cuba

COUNTRY OF ORIGIN
USA

TECHNIQUE
Computer animation

FORMAT
16mm, black & white

LENGTH
6 minutes

YEAR
1985

Born in Atlanta, US, in 1950, Larry Cuba is a pioneering computer animator who actively made films from the early 1970s to the mid-1980s. Cuba has been described as being part of the second generation of computer animators, following in the footsteps of 1960s gurus, such as John Whitney Snr. and Stan VanDerBeek.

Cuba attended Washington University, US, between 1968 and 1972, majoring in architecture. This early love of form, function and structure is clearly present in all of his works, and he has a life-long interest and passion for what he has described as the 'connection between mathematics and art'.

He gave up architecture in 1972 and went instead to the California Institute of the Arts (CalArts). He attributed this dramatic change in career direction to the irresistible potential offered by computer animation. He has commented: 'I was originally attracted to architecture because of my interest in geometry and three-dimensional form. When I discovered that mathematics could be used to generate animating geometric form via computer graphics I realized that I had to do that. The direct connection between algebra, music and abstract form appeared as a vast new territory for exploration.'

Like many experimental animators before him, Cuba was self-taught – while he was at CalArts he was keen to explore the potential of computer-driven graphics, although the subject was not yet being offered to students. He found access to the NASA Jet Propulsion Lab and taught himself programming. By 1974 he had made his first film, *First Fig*, on a Univac 1108 mainframe.

In 1975, John Whitney Snr., one of his heroes, invited Cuba to work on a film with him. The resulting masterpiece was *Arabesque*. Their collaboration involved Cuba implementing his mathematical ideas in computer software, which gave him a first-hand insight into the inner workings of Whitney's theories of digital harmony.

Cuba has since produced more computer-animated films: *3/78 (Objects and Transformations)* (1978), *Two Space* (1979) and *Calculated Movements* (1985). These works have been shown at film festivals throughout the world and have won many awards. Cuba has received grants for his work from the American Film Institute and the National Endowment for the Arts, and he was awarded a residency at the Karlsruhe Centre for Art and Media Technology (ZKM) in Germany. While he was artist-in-residence at ZKM in 1995–96, Cuba began work on a software development project that he says will eventually result in another film or installation.

In the meantime he continues to work as executive director of the iotaCenter in Los Angeles, a non-profit-making organization he founded to promote the art of abstraction in the moving image. Of Cuba's influence on computer animation, Raphael Bassan wrote in a 1981 issue of *La Revue du Cinema*: 'In the sphere of abstract cinema (lacking a better term), Larry Cuba's research is, in fact, at the origin of a new direction which does not yet have a name.'

Calculated Movements (1985) is a sequence of graphic events, made up from simple elements, which are choreographed so that they repeat and combine in an ordered structure. The simplest element is a linear, ribbon-like figure that takes a path across the screen before disappearing. The most complex level is the sequential arrangement of the graphic events into a score that describes the composition from beginning to end.

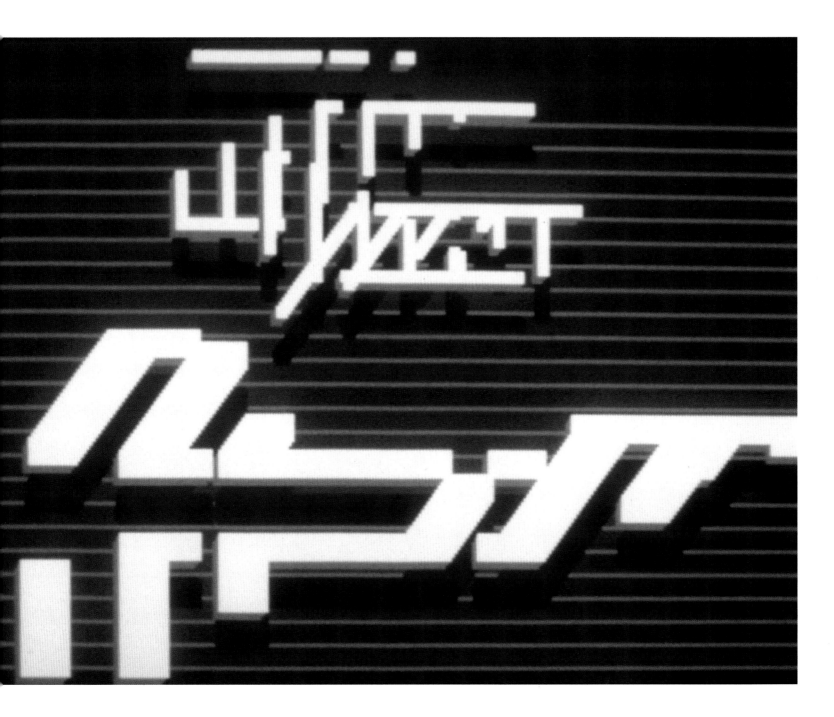

DYLAN KENDLE

TITLE
Third Interpolation

DIRECTOR
Dylan Kendle

COUNTRY OF ORIGIN
UK

MUSIC
Edgar Varèse

FLAME ARTIST
Duncan Horn

TECHNIQUE
Elements shot on 16mm and composited in Flame

FORMAT
Digital

LENGTH
3 minutes, 9 seconds plus titles

YEAR
1999

'My interest in animation and motion graphics probably stems from two events,' says Dylan Kendle. 'The earliest was being shown Len Lye's work for the General Post Office [Film Unit, UK] by my stepfather when I was in my teens. The second was meeting Graham Wood [from art and design collective, Tomato] and seeing his work. I was privileged to work with Graham and Jon Hollis on some early projects for Underworld, and the fluidity of the process and partnership fascinated me. The speed at which beautiful things appeared in front of my eyes astounded me – it still does. I still get a rush when something beautiful happens: it's a smug rush when it's something you've planned, but I'd never discount the happiest accidents.'

Born in Norwich, UK, in 1971, Dylan Kendle studied graphic design at Camberwell College of Art in London, where he says he just wanted to 'draw and draw'. But the meeting with Graham Wood introduced him to moving imagery and subsequently led to his joining Wood at Tomato. Shortly afterwards he was given the opportunity to design the film titles for Danny Boyle's film, *Trainspotting* (1996). 'It's difficult to imagine now, but at the time it was just a nice little job,' Kendle says. 'Tomato was very much a collective: jobs were shared unless there was a previousl[y] established contact, and when new jobs came in it came down to who was interested and available. When the *Trainspotting* titles came in Jason [Kedgley] and I wanted to work on them together. I've since heard people describe it as a seminal piece of work, and we were subsequently short-listed for Designer of the Year, but I was about 24 years old and I'd only been out of college for just over a year! Of course, the accolades are always wonderful, but I guess I d[o] get tired of being introduced as the guy who did ...'

Kendle left Tomato after about 18 months and has worked as a freelance director/designer ever since, signed to London production company Pink for commercials, which he has shot for organizations such as Adidas, BMW and Orange. He is currently working on a multi-screen art installation for a gallery in Rome, Italy, while he continues to work in print (as creative director of two experimental music labels, Peacefrog and Vertical Form) as well as making personal short films such as *Poetry and Violence* (1998), *2 Squares* (2000) and *Third Interpolation* (1999).

'I think that if there is a recurring motif in my work, it's an unhealthy interest in geometry and my short films serve to purge me of such desires,' he jokes. Certainly, grids and abstract shapes feature in his career so far, while music is also always an important factor. 'Sound is of paramount importance – it can help to make a circle sinister,' he says firmly. 'Personally I like work that has a simple idea which is well executed. Anything from Norman McLaren's *Pas de Deux* or Saul Bass's titles for *Vertigo* to Lambie Nairn's BBC2 idents or Michel Gondry's promos for The White Stripes.'

Using music by composer Edgar Varèse, **Third Interpolation** (1999) features shapes projected within an abstract environment. The movement and scale of the forms within the film beautifully echo the dynamic of the soundtrack.

TITLE
Sink

DIRECTION, DESIGN AND MUSIC
Tomioka Satoshi

COUNTRY OF ORIGIN
Japan

MUSIC
Tomioka Satoshi

TECHNIQUE
Computer graphics

FORMAT
Digital

LENGTH
3 minutes, 40 seconds

YEAR
1999

TOMIOKA SATOSHI

Born in Nagoya in Japan in 1972, Tomioka Satoshi was brought up in Tsu but went to Tokyo to study hydrodynamics at the postgraduate school of Agriculture and Technology at Tokyo University. He became interested in computer graphics during these years, working as a part-time operator at a graphics company. He began to work full time at Dream Pictures Studio after he graduated from university.

The studio closed down in 1999, and the shy and reclusive Satoshi took a break from creating computer graphics, although he used this time to begin his own experiments. His first film, *Sink* (1999), was based around his own experiences of travelling on packed commuter trains in Tokyo. For the film he transposed businessmen into a vivid, underwater world, complete with divers ogling porn magazines and getting in each others' way. His films are innovative in technique and marked by a flavour of black comedy, which pokes fun at *otaku* culture, the obsessive and rogue loner elements in Japanese society.

Satoshi continues to work on personal projects, and he remains something of a modern-day renaissance man: not only does he devise and write the stories of his films, but he also composes and performs their soundtracks himself. His bright, primary colour-saturated graphics and detailed, futuristic landscapes are a world away from the *manga* style that has for so long been predominant in Japan, and it was perhaps this that meant his work caught the eye of various international commercial clients, including the Japanese rail network, JR, and Honda Europe, for which he created an advertisement through his London production company, Nexus Productions.

Satoshi has also worked on music promos for DJ Hasebe, among others, and created short films such as *Coin Laundry XYZ* and *Gastank Mania* (both in 2000). 'Tomioka Satoshi's films herald the emergence of a unique talent in 3D,' says Chris O'Reilly, who co-founded Nexus Productions with fellow producer Charlotte Bavasso. 'Tomioka-san is not a product of the massive Japanese studio animation industry, but one of the first in a new generation of Japanese artists who have learned their animation on a personal computer. You can see that his work has developed and flourished under the specific structures of working mostly alone. He has a fantastically idiosynratic sense of design.'

Another short film, *Game Shingo* (2001), stars two members of male-model boy band, SMAP, as three-dimensional animated characters in a colourfully nightmarish game centre. Despite this, he remains somewhat ambivalent towards the short film medium, and his main ambition is still to make a feature film. Meanwhile, he is planning to create a series featuring the continued exploits of the mask-wearing hero of *Gastank Mania*.

Sink (1999) presents the brightly coloured, futuristic world of the Japanese commuter, drawing on director Tomioka Satoshi's own experiences of packed commuter trains in Tokyo. Here, however, the business men are all deep sea divers.

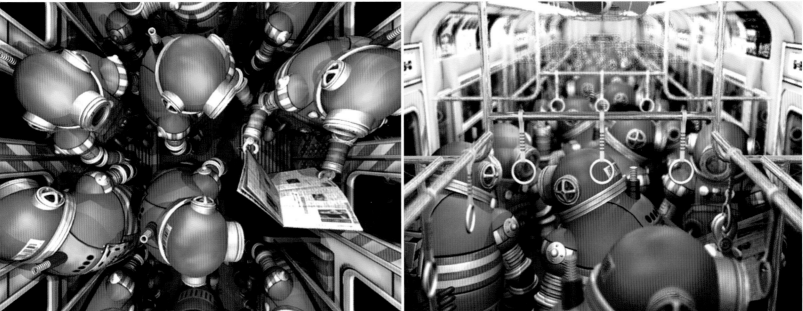

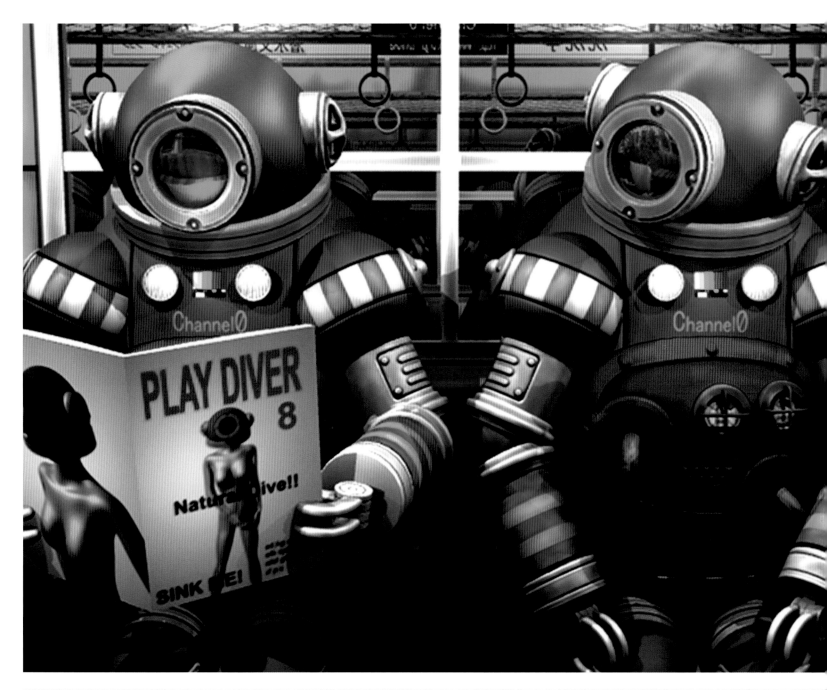

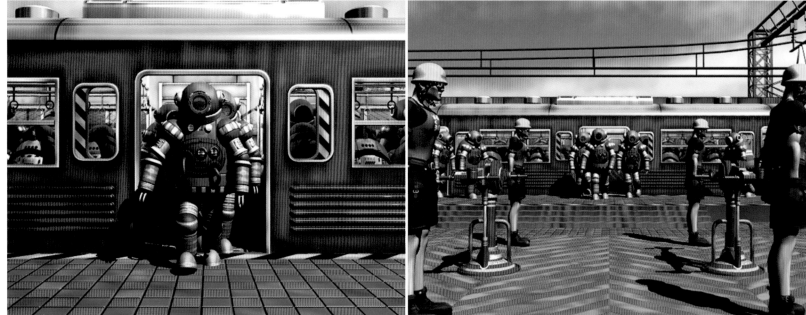

TITLE
The Wolfman

DIRECTOR
Tim Hope

COUNTRY OF ORIGIN
UK

CO-AUTHOR AND VOICES
Waen Shepherd

SOUND AND OTHER VOICES
Tim Hope

MUSIC
Samples from Igor Stravinsky and Manuel Cardoso

ILLUSTRATIONS AND SET DESIGN
Bartek Kubiak

THANKS
Gilles Gobeil and Kazuko Hohki

TECHNIQUE
Drawing, 3D studio max, 64MB pentium II computer

FORMAT
Mini DV

LENGTH
6 minutes, 30 seconds

YEAR
1999

Tim Hope, who was born in Greater Manchester, UK, in 1969, took a rather circuitous route into full-time directing and animation. Having studied theology and philosophy at Exeter University, he began experimenting with music and stand-up comedy, eventually beginning to integrate short animated films into his performances at clubs such as Omsk and Hallowe'en. 'I was just dabbling, I'd be drawn in and make an animation for a performance and then forget all about it and go back to sound or directing,' he says. 'I'd do it really quickly, make a 7-minute animated film in a week and then suddenly I realized that basically I was possibly slightly better at the animation than I was at the performance. I was entirely reluctant to accept this, in fact I still resent the fact I feel like a failed performer.'

Making a 7-minute film in a week does rather go against the traditional idea of animators working on their masterpiece for years on end, but Hope remains defiant: 'I always give myself a deadline, that's one thing I'm quite rigorous about. I don't want to get lost for two years.' Having said that, he did spend four months working on his one short film to date, *The Wolfman* (1999), an extension of a one-minute piece he originally created as part of a performance piece. 'I knocked out the first 5 minutes and wasn't really that bothered but when I got to the end I realized what I wanted was for everything to go as massive as possible,' he says. 'I'd already written the sound, and if the images were to keep up with that energy they needed to be quite intricate and indepth, so I had to keep working on them. Essentially, I realized I wanted it to be good.' A reworking and shortened version of *The Wolfman* has since been produced as a commercial for Sony PlayStation 2.

Currently signed to London production company Passion Pictures, Hope has made a name for himself directing promos groups such as Coldplay and One Giant Leap, but he intends to take time off to dedicate himself to making a series of short films. 'My pop videos are desperate attempts to make short films,' he says. 'I realized when we did some remixes of some of the videos, using different music, that they worked really effectively. Then I realized that was actually a problem: making a video for the song wasn't really my starting point and that's what a video should be. So I thought I'd better get on and make some short films rather than use pop videos to do it.'

It is, he admits, a nervewracking time: 'I haven't sat down and asked myself what I want to say as a filmmaker. And it might be really boring,' he says, only partly tongue-in-cheek. 'It's terrifying, I've spent the last two years imagining how brilliant I was going to be when I sat down to do this and it might turn out I have absolutely nothing to say.' On current form he shouldn't worry too much.

Tim Hope's award-winning **The Wolfman** (1999) tells the story of an astronomer who transforms himself into a werewolf in the search for an exciting, although destructive, adventurous life.

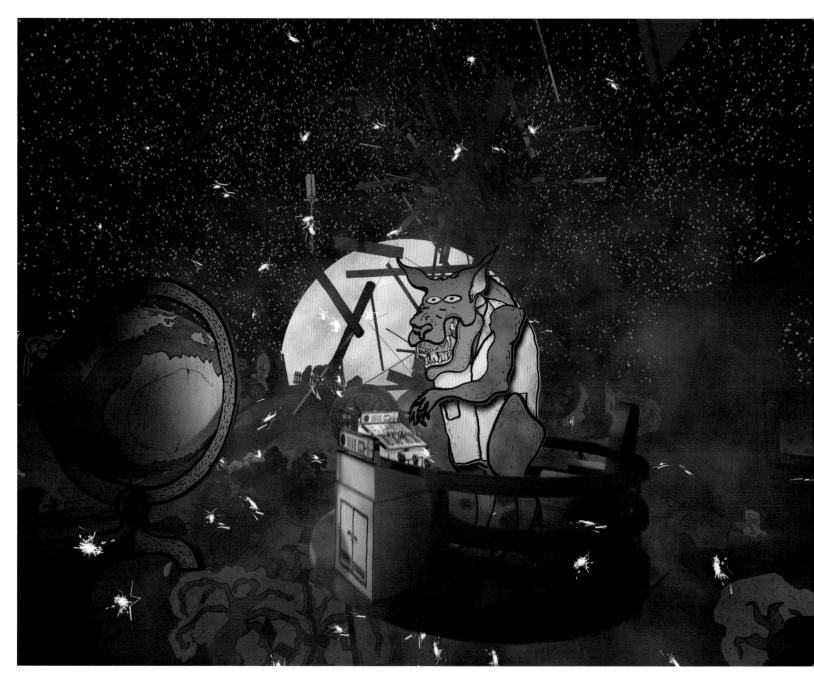

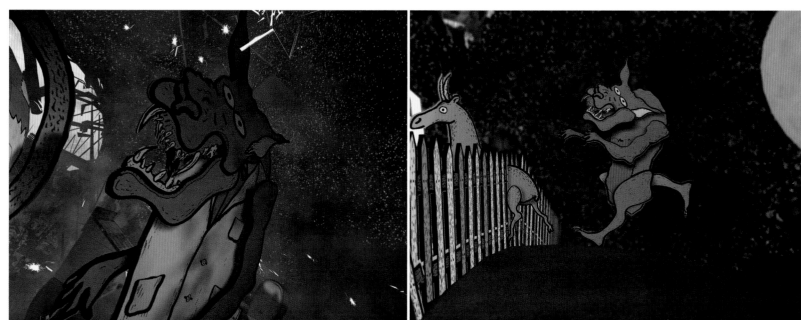

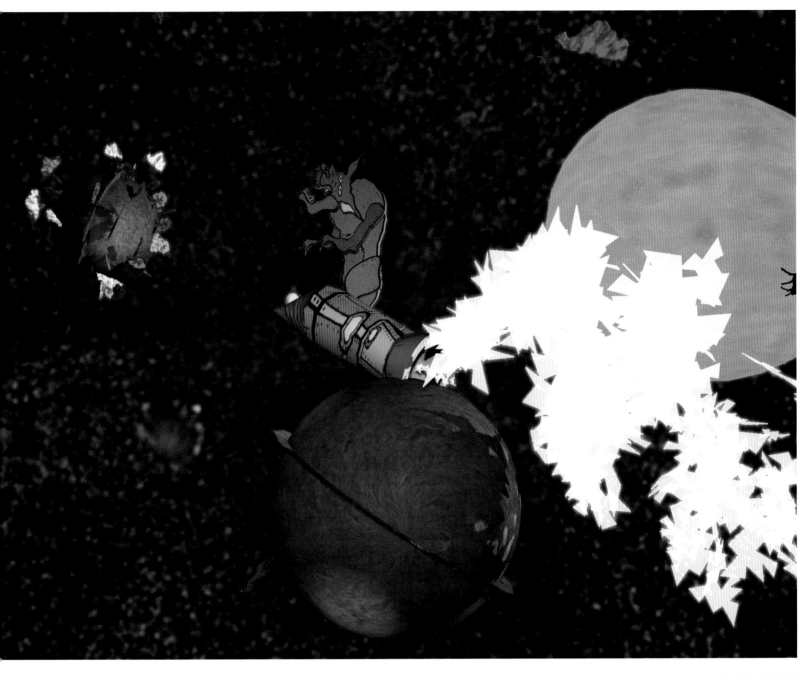

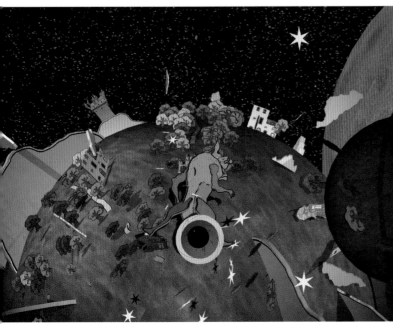

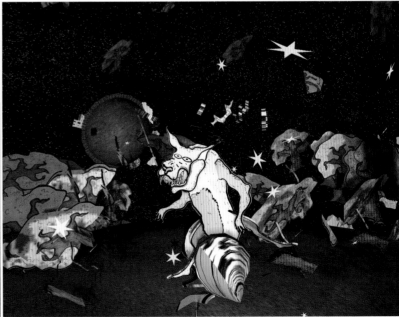

TITLE
In Absentia

IMAGES
Brothers Quay

COUNTRY OF ORIGIN
USA

PRODUCER
Keith Griffiths

PRODUCTION
Koninck for the BBC and
Pipeline Films

MUSIC
Karlheinz Stockhausen

ACTRESS
Marlene Kaminsky

PROJECTION
Scope

TECHNIQUE
Live action, puppet animation

FORMAT
35mm, 8mm, colour and black
& white

LENGTH
20 minutes

YEAR
2000

Born in the US in 1947, twin brothers Stephan and Timothy Quay initially studied illustration at the Philadelphia College of Art before moving to London to continue their studies at the Royal College of Art. They began to experiment with animation, making three two-dimensional animated films in their spare time. After the release of their first puppet film, *Nocturnia Artificialia,* in 1980, they founded their own production company, Koninck, with fellow former student Keith Griffiths.

The brothers' background in illustration shows throughout their work (both are expert calligraphers and they have also designed some beautiful, intricate book covers). Indeed, their miniature sets and backgrounds are as carefully considered as the characters they portray: 'We ask our machines and objects to act as much as if not more than the puppets,' they explain. Their work also resounds with references to their other enduring passion for central European culture.

The brothers do not restrict themselves to working on short films, however, and they have also directed advertisements for companies such as Dulux and Nikon and documentaries on the music of Igor Stravinsky and Leos Janácek. They have also been responsible for some extraordinarily memorable music videos – *Sledgehammer* for Peter Gabriel in 1986 was the result of their collaboration with Aardman Films – and they have designed numerous theatre and opera sets. They directed their first full-length, live-action feature film, *The Institute Benjamenta*, in 1995 and are currently in pre-production on their next feature, *The Piano Tuner of Earthquakes*.

Short films remain a favoured medium, however, and to date they have made some 20 puppet- and-object animation shorts. Most recently, they collaborated with the avant-garde composer Karlheinz Stockhausen to create the film *In Absentia* (2000). The film takes the viewer inside the mind of one Emma Hauck, a patient in an asylum, who compulsively wrote letters to her absent husband. 'We first saw her letters at the "Beyond Reasoning" exhibition at the Hayward Gallery in London, and they were an absolute revelation to us,' the brothers explain. 'Although we had known about this area of the "art of the insane" for a long time, we had never seen these particular examples and they utterly terrorized us. We decided to conceive a film around one of her letters based on the idea that Stockhausen's music would curiously release both us and the letter from their stillness.'

Music and sound design form an integral part of the Quays' work: 'Ultimately it's about creating an absolutely invisible synthesis between music and image,' they say. 'The role of light in this film was above all the dynamic catalyst, with the electricity of Stockhausen's music, through which virtually every image was filtered as though from the point of view of the brain's membrane.' For his part, Stockhausen was so moved by the film the brothers had created that he broke down in tears the first time he saw it. 'It comes from two brothers who obviously have an inner world of imagination that other people don't know and don't have,' he said. 'Having seen this film one feels that one's inner windows and spaces have been opened.'

In Absentia (2000) presents Emma Hauck, a schizophrenic patient confined to an asylum in the 1910s, who compulsively wrote letters to her absent husband. The exquisitely detailed environment and eerie, claustrophobic atmosphere work perfectly with the electronic soundtrack (by Karlheinz Stockhausen) to present a tragic insight into her mind and her world.

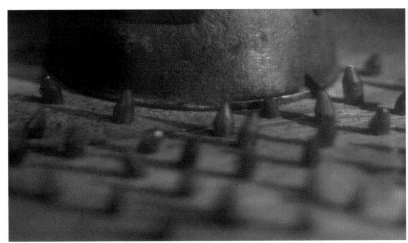

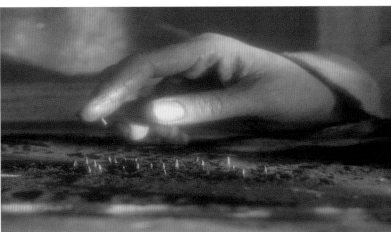

TITLE
Monocodes

DIRECTOR AND DESIGNER
Alexander Rutterford

COUNTRY OF ORIGIN
UK

PRODUCTION COMPANY
Lost in Space

SOUND DESIGN
Alexander Rutterford

TECHNIQUE
Digital filmmaking

FORMAT
DVD/video

LENGTH
5 minutes, 20 seconds

YEAR
2000

Born in Newmarket, UK, in 1970, Alexander Rutterford initially trained as a graphic designer, studying at Lowestoft College before graduating from Croydon School of Art in 1990. 'I was formally trained before the advent of computer technology, so almost everything I did was hand drawn or some form of photo-manipulation and rub-down lettering. There's a real skill to getting something to look good without the aid of a computer and I loved that craft … The computer makes graphics easy but can be a bit like fast food: cheap and nasty but it does the job. Things have got better since then, especially in the field of experimental design, but there's still so much rubbish around.'

A brief stint at London graphic design agency Me Company introduced him to a whole new three-dimensional world, which proved something of a revelation. 'Computer animation just blew my mind when I got my hands on it,' he enthuses. 'I could take graphic design principles and 3D aesthetics and apply those to a three-dimensional world with sound. It never fails to give me a sense of enjoyment, there's so much to explore.' Rutterford then moved to work at production company, Lost in Space, before turning freelance in 2000.

Music remains a constant source of inspiration for Rutterford, whose commercial clients include experimental electronic artists, Autechre, Amon Tobin and Squarepusher. 'To be honest, I don't really follow other 3D creatives or artists in that field,' he admits. 'Futurism and Constructivism have had an enormous influence on me, but music definitely remains my best form of inspiration. When I work on a promo, I try to reflect the music, what it does for me visually in my head.' In the case of his extraordinary promo for Autechre, this entailed assigning a different graphic to every separate sound, to fantastic effect.

The commercial world proves somewhat frustrating for Rutterford, who admits he finds it all both bewildering and irritating. 'What frustrates me most is that people just don't have the will to let you explore new territory and give you a new commission because they feel that your work is "too experimental", "too extreme" or "too aggressive" or they can't see what you could bring to a new project,' he says. 'But I think it's always to your benefit to try and get the best out of a commercial project and use the opportunity to explore new areas.'

As such, he spends much of his time concentrating on personal projects, such as *Monocodes* (2000). 'Personal work and experimental films involve a little bit of cross-breeding with sound and music and graphic concepts that I explore and fit to certain music,' he continues. 'The actual production is just a very hard, long process to get what I originally envisioned.'

Monocodes (2000) contains a series of vernacular sounds designed by Rutterford. 'They're the kind of sounds that occur in the modern world, but you don't always remember them or look out for them,' he explains. 'The visuals are abstract representations of those sounds.'

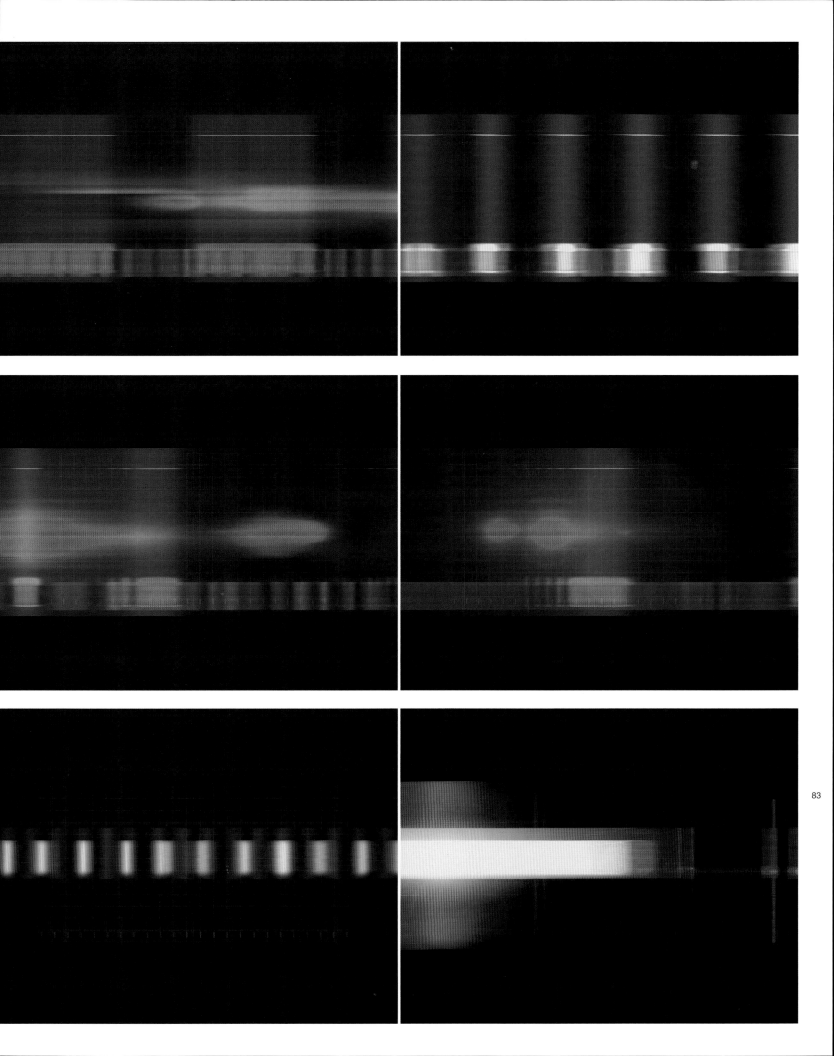

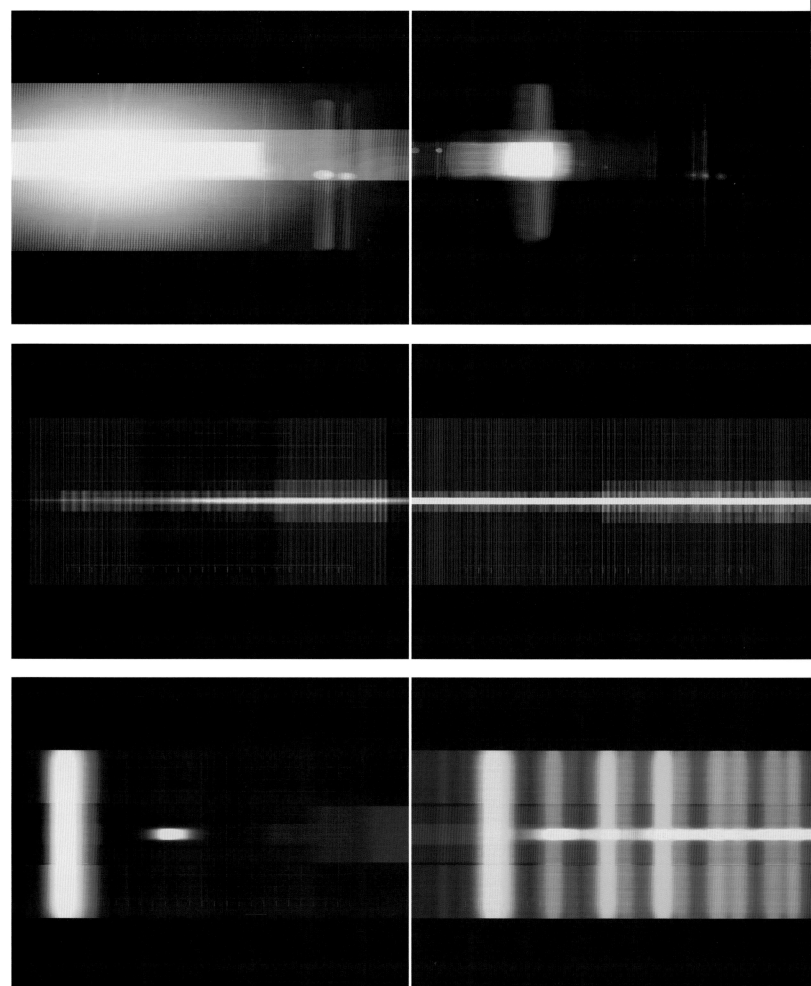

86

TITLE
Bleip: No

DIRECTORS
Geneviève Gauckler,
Jean-Philippe Deslandes

COUNTRY OF ORIGIN
France

PRODUCTION COMPANY
Pleix

MUSIC
Bleip (Jean-Philippe Deslandes)

TECHNIQUE
Photoshop, Flash, Vegas Video,
After Effects

FORMAT
Mini DV

LENGTH
2 minutes, 53 seconds

YEAR
2001

WEBSITE
www.pleix.net

PLEIX

The French collective Pleix consists of six graphic designers (Geneviève Gauckler, Jean-Philippe Deslandes, Olivier Lipski, Eric Augier, Erwin Charrier and Michel Metenier) and one project manager (Laetitia Rouxel). They met while they were working with directing duo, Olivier Kuntzel and Florence Deygas, and branched out to concentrate on their own projects, officially founding Pleix in early 2001. 'We like to give ourselves lots of creative freedom,' explains Rouxel. 'Our philosophy is to share skills and make great projects. We all get inspiration from many different sources, while we also like to mix together different techniques and different worlds.'

The organization's set up is left deliberately loose, so that members can collaborate in small teams or as a single group, whichever works for that particular project. Geneviève Gauckler and Jean-Philippe Deslandes often work together on projects such as *Bleip: No* (2001). 'I really like the contrast in Geneviève's work,' says Deslandes. 'Soft shapes mixed with hard ones, a sort of "pretty violence". I like to trash the perfect side of the vector animations by adding accidents, pixellating them, that kind of thing.'

'Jean-Philippe deals with the rhythm of the video and the way all the sequences are put together,' adds Gauckler. 'He deals with the tricky editing part and makes the images coincide perfectly with the music: it's a huge work. For my part, I generally only have a vague idea about colours, shapes and type at the beginning of a project. I have a very two-dimensional way of working.'

Many of Pleix's films project a deliberately dark, skewed vision of society. *Beauty Kit* (2001), for instance, portrays beauty treatments for children: with its bright, colourful graphics and upbeat music, it takes the viewer a while to realize that the 'ads' are promoting breast enlargement or plastic surgery kits, while the graphics are violent and explicit. *Simone* (2001), meanwhile, presents an increasingly frantic version of the children's game, Simon Says.

Although they continue to work with commercial clients, the members of Pleix remain most interested in pursuing their own various visions, though they admit it is hard to find either the time or the funding for their projects. 'The situation in France is very difficult,' says Gauckler. 'Pop promos are not broadcast on any TV channel, except sometimes on a cable channel that nobody watches. It is very frustrating. France is a great country for cinema but not for creative video: there are very few festivals of animation here, certainly nothing celebrating digital video. There seems to be some kind of unwritten hierarchy that says that cinema rules supreme while the rest has no value.'

'It is a pity that most animation films have such a short life,' agrees Deslandes. 'But I feel the same thing happens to many films and music too. Hopefully, things are beginning to change with the potential of the Internet.'

Bleip: No (2001) uses designer Geneviève Gauckler's combination of violent and pretty imagery together with music by Jean-Philippe Deslandes. The film is Gauckler's punk treatise. 'It presents a series of words but says "no" to everything,' she explains happily. 'The idea was to express a feeling of malaise, of soft agressiveness.'

HAN HOOGERBRUGGE

TITLE
Flow

DIRECTION AND ANIMATION
Han Hoogerbrugge

COUNTRY OF ORIGIN
Holland

PRODUCTION
Han Hoogerbrugge

MUSIC
Gil Kay, Wiggle

ADDITIONAL SCRIPTING
Jeroen Bertman

TECHNIQUE
Flash projection

FORMAT
Digital

LENGTH
N/A (interactive animation)

YEAR
2001

WEBSITE
www.hoogerbrugge.com

Dutch visual artist Han Hoogerbrugge was born in Rotterdam in 1963 and studied painting at the city's Art Academy. After graduating in 1987, he began to experiment with many different media, including drawing, installation and sculpture. In 1996 he drew a comic strip starring himself, portraying the everyday problems artists face in trying to get their work seen and sold.

After getting an Internet connection in 1997, he decided to post these illustrations online. 'As I got more familiar with HTML and all the basic rules involved with publishing on the Internet, I realized that this wasn't the right medium for a static comic strip,' he says. So, although he confesses to having had only a passing interest in animation – in particular, *Road Runner* and *Beavis and Butthead*, 'like everyone else, for entertainment' – he began to experiment with the discipline. Within two years he was working on the *Neurotica* series, an Internet-specific work for which he used simple GIF- (Graphic Interchange Format) technology to loop his animations.

In 1998 Hoogerbrugge was invited by the Dutch television company Vpro to create an interactive version of *Neurotica* (1998–2001), and so began his experiments with Flash. 'I had admired Flash work on the Internet, but this was the first time I had found the chance to start working with it,' he says. 'With this series I wanted to do something else. I wanted to explore what it's like to be alive in the time we live in, in a general way. To visualize the spirit of our time through the adventures of my character. With no language, just images.'

The resulting series features his characteristic, wry, off-beat look at life. Quirky and amusing, it both entertains and provokes the viewer, although Hoogerbrugge professes not to aim for any one particular reaction with this or any of his subsequent works, such as *Square Pig in a Round Hole* (1999–2000) or *Flow* (2001). 'I'm satisfied if people can in some way relate to my world and recognize what is going on without really understanding it,' he says happily.

Music remains a central part of much of Hoogerbrugge's animation work. 'I think music, sound in general is very, very important,' he says firmly. 'It's the glue that keeps the images together. Some of the animations I have made would not work at all without sound. *Flow*, for example, is meaningless without sound.'

Most of Hoogerbrugge's time is now taken up with animation, working as he does on a freelance basis for a wide range of international clients, from the Dutch television company Tros to the multinational corporation Sony PlayStation 2.

Flow (2001) follows the progress of its star (and creator) Han Hoogerbrugge through a succession of incidents, which can be altered or enhanced by interactivity from the viewer. 'As with much of my work, it deals with what it means for me to live in our time,' says Hoogerbrugge. 'A private battle with religion, health, sports, pills and death.'

JEAN-LUC CHANSAY

TITLE
Eyen

DIRECTION, DESIGN AND ANIMATION
Jean-Luc Chansay

COUNTRY OF ORIGIN
France

DRAWING
Tess Mercier

SCULPTURE
Marie Mercier

MUSIC
Plaid, published by Warp Music

TECHNIQUE
Computer animation, Move 2D,
Compositing 2D–3D

FORMAT
DV

LENGTH
4 minutes, 20 seconds

YEAR
2001

WEBSITE
www.designer1.free.fr/
indextemp.html

Born in Paris in 1965, French artist Jean-Luc Chansay has worked in many different creative disciplines thoughout his career, including writing music (at one point he was signed to EMI), designing clothes and products and creating websites. 'I consider myself a self-starter,' he says modestly. 'I have always admired people who work passionately on their own, personal projects.'

His first foray into animation came in the 1990s, when he began to experiment with programs on his home computer. 'At the time I was the creative director at a web design agency,' he explains. 'But after the euphoria and excitement of the boom period, I quickly began to feel a sense of frustration: the majority of our customers were very large companies, and despite the fact that I was the creative director, my sphere of activities was very limited. I found a solution for this creative frustration by producing small animated clips for my favourite pieces of music. With these I found those "magic moments" of creativity that all artists know about.'

One of these magic moments came in 2001 with a short film he made using the track *Eyen*, written by British electronic band, Plaid. Featuring the drawings of Chansay's daughter, Tess, and the sculptures of his partner, Marie Mercier, this beautiful, evocative film came to the attention of the band members, who were so impressed that they immediately pushed for the video to be released by their label, Warp Records. 'I love to animate using Tess's drawings,' Chansay says proudly. 'She draws every day and is generally better than me, she is already an artist. In my opinion, the most important thing is to make sure that your work preserves some kind of freshness, and I am constantly inspired by her vision.'

'It is not easy to make a living creating short, experimental films,' Chansay admits. 'But I've always been carefree and have simply pursued my passions, never with a fixed plan of building or planning my future. I firmly believe it is necessary to make a distinction between passion and money.' As such, although he continues to work as a freelance web designer and animator, he also continues to experiment with various styles and techniques of animation, consistently using music as his starting point. 'Music brings my inspiration,' he says. 'I let myself drift into my imagination, and it is generally at these moments that fortunate coincidences occur, when the creator becomes the witness and events are uncontrolled and unforeseen. I consider that these signs are an indicator that I am on the right track and that the final result will at least be interesting!'

Eyen (2001) features a bizarre mechanical dream world composed of line drawings, which were created by Jean-Luc Chansay's daughter, Tess (then just five years old), and metal sculptures, which were designed by his partner, Marie Mercier.

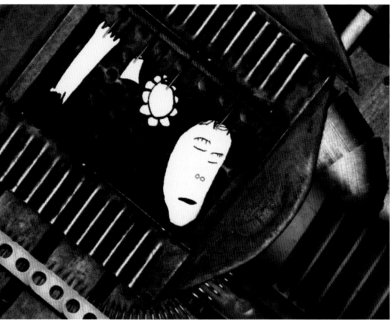

'I am still convinced that poetry is the foundation of all forms of art, that it stands in their centre and all the rest are but means for grasping it. That also applies to animation. The means are interchangeable,' says the admired Czech filmmaker Jan Svankmajer. His animated film *Jabberwocky* (1971), a version of Lewis Carroll's poem, was his first interpretation of the author's work; he later went on to make a feature film based on Carroll's classic book, *Alice's Adventures in Wonderland*.

Poetry and writing have provided the inspiration for many animation filmmakers, wh use texts by famed authors, such as Lewis Carroll, and also less widely known writers, such as Mordecai Richler, on whose short story Caroline Leaf based her beautiful film, *The Street* (1976). Frédéric Back was so profoundly moved by Jean Giono's story *The Man who Planted Trees* (1987), that he made it into a film: 'It was a privilege to work on such a rich and profound tale that has a biblical message of hope and generosity,' he explains. And, of course, directors also collaborate directly

WORDS

with authors. Yuri Norstein, for instance, worked with playwright Ludmila Petrushevskaya to create *Tale of Tales* (1978).

The nature of animation means that stories do not have to be interpreted literally, but that films can be a genuine extension of the author's artistry. Philip Hunt's film, *Ah Pook is Here* (1994) uses author William Burroughs's own recordings of his poetry but is a genuinely original vision in its own right. Jonathan Hodgson adapted a Charles Bukowski poem for his film *The Man with the Beautiful Eyes* (2000), and Pau Bush's film *The Albatross* (1998) presents his take on Samuel Taylor Coleridge's classic poem *The Rime of the Ancient Mariner*. The decision not to name the film after the text on which it was based was deliberate: Bush was keen that people should view his work on its own merits.

Text can feature in more literal ways too. Christine Panushka intercut the images of her graduation film *The Sum of Them* (1984) with type. Stuart Hilton's work, *Save Me* (1994), is a semi-abstract film which takes doodles and found messages as its starting point. 'I've never had any stories to tell as such and feel strongly that the only way for me to work is intuitively and spontaneously within the medium using only processes peculiar to that medium. In other words, it should not be able to be written or described accurately, translated or adapted meaningfully from or between other art forms.'

American filmmaker, George Griffin explores the tension between text and the visual in many of his films. 'Because animation must often bear the burden of merely illustrating a privileged text (poetry, advertising haiku, pop lyric) I have tried to restore a kind of equilibrium between word and image,' he says. '*Head* [1975] uses a variety of strategies to ironically deconstruct my own (the artist's) directly-addressed sincerity.'

Other directors simply do it all themselves. San Francisco-based director Lev Yilmaz writes his own scripts, which he then narrates himself for the deceptively simple-looking series, *Tales of Mere Existence* (2001). 'Getting the script right is the most consuming part,' he says. 'I always record the audio first to make sure the story flows well.' London-based director Johnny Hardstaff's film *The Future of Gaming* (2001) centres on the increasingly frantic voiceover of an executive of a fictional games company, with a succession of abstract, often violent animation images providing the perfect accompaniment to the diatribe she is uttering. Dutch-Canadian director Paul Driessen, meanwhile, tells stories without using spoken word. In his film *The End of the World in Four Seasons* (1995) he expermiments with narrative by splitting the screen into eight different panels, each with inter-connecting themes and imagery. It is, he says, a 'careful balance between storytelling and too much information'.

JAN SVANKMAJER

TITLE
Jabberwocky

SCRIPT, DESIGN AND DIRECTION
Jan Svankmajer

COUNTRY OF ORIGIN
Czechoslovakia

PRODUCTION COMPANY
Kratky Film (Prague) for
Western Wood Studio (USA)

PRODUCER
Jiri Vanek, Erna Kminkova,
Marta Sichova

PHOTOGRAPHY
Boris Baromykin

EDITOR
Helena Lebduskova

ANIMATOR
Vlasta Pospisilova

MUSIC
Zdenek Liska

TECHNIQUE
Puppet animation

FORMAT
35mm, colour

LENGTH
13 minutes

YEAR
1971

Born in Prague in 1934, Jan Svankmajer is credited with having had a huge influence on many later artists, from the Brothers Quay to Johnny Hardstaff. His fascination with animation began when he was given a puppet theatre for Christmas in 1942. He later went on to study at the Prague Academy of Performing Arts (DAMU), where he specialized in puppetry, direction and set design. He also became particularly interested in Soviet avant-garde theatre and film. 'Meyerhold and Taïrov were my heroes, together with [Sergei] Eisenstein and [Dziga] Vertov,' he says. His graduation film used a combination of puppets, live actors and actors dressed as puppets, techniques he later used in films such as *The Last Trick* (1964), *Don Juan* (1970) and *Faust* (1994).

In 1960 Svankmajer founded the Theatre of Masks, part of the Semafor Theatre in Prague, and he later joined the prestigious Magic Lantern Theatre before branching out to make independent films. It was he was while preparing for the first production at the Theatre of Masks that he met his future wife, Eva, a respected Surrealist painter in her own right, with whom he has since collaborated on many projects. Svankmajer himself became an official member of the Czech Surrealist Group in 1970, an avowedly pivotal moment in his career.

In 1972, following the release of his film *Leonardo's Diary*, which featured unauthorized portrayals of everyday life in Czechoslovakia, Svankmajer was banned from making films for seven years. During this enforced hiatus, he spent much of his time working as a special-effects designer at the Barrandov Film Studio, where he created title sequences for various films. He also continued to draw, paint, sculpt and write and began work on a series of 'tactile experiments' which greatly influenced his later films.

Permitted to make films once again in 1979, Svankmajer was nonetheless restricted to adapting literary texts, which led to his productions of Horace Walpole's *The Castle of Otranto* (1977) and Edgar Allan Poe's *The Fall of the House of Usher* (1981). However, he again ran into trouble with the authorities in 1982 with his multi-award winning short, *Dimensions of Dialogue*. Not only was the film banned in Czechoslovakia, but it was even shown to the ideology commission of the Central Committee of the Czechoslovak Communist Party as an example of the kind of film that should not be made.

To date, Svankmajer has made more than 30 films, both short and feature-length, as well as pop videos (for the likes of Hugh Cornwell of The Stranglers) and films for MTV. He draws inspiration from a wonderfully diverse range of sources, from Lewis Carroll and the legendary Bohemian emperor, Rudolf II, to the painter Giuseppe Arcimboldo. He founded the Athanor film studio with his regular producer Jaromir Kallista in the village of Knoviz in 1991 and continues to make films. He was awarded the lifetime achievement award at the World Festival of Animated Films in Zagreb, Croatia, in 2000.

Jabberwocky (1971) was Svankmajer's first interpretation of the work of Lewis Carroll, of whom he has said 'mentally, we're on the same side of the river'. The precursor to his feature film, *Alice* (1987), *Jabberwocky* features an extraordinary series of inanimate objects coming to life, all to the voiceover of a young girl reading Carroll's poem about the Jabberwock.

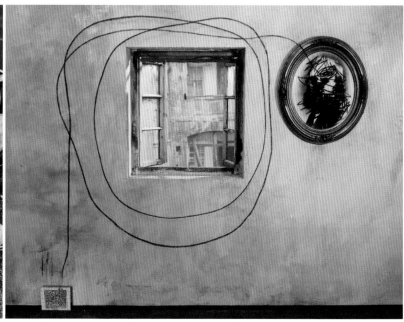
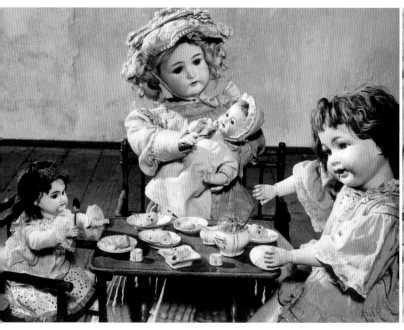
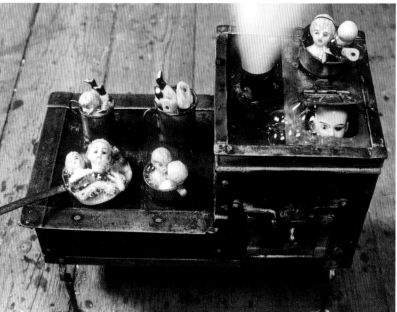

GEORGE GRIFFIN

TITLE
Head

DIRECTOR
George Griffin

COUNTRY OF ORIGIN
USA

MUSIC
Fred Israel

TECHNIQUE
Photography, drawing, film

FORMAT
16mm, Betacam SP

LENGTH
10 minutes, 30 seconds

YEAR
1975

George Griffin didn't actually set out to be an animation director. Born in 1943 in Atlanta, Georgia, he studied political science at Dartmouth College in New Hampshire. However, while he was there, he created a cartoon strip for the university literary magazine *Greensleeves* (Griffin's father was also a newspaper cartoonist) and was impressed by lectures from visiting filmmakers, such as Stan Brakhage and Robert Breer. 'These film explorers were my introduction to animation as an experimental form, which might include drawing, photography, scratching or burning,' he says.

Even so, after graduating Griffin initially worked in a government office, although he kept working on his own film experiments in his spare time. Having received encouragement from influential figures, such as Fred Mogubgub, he finally gave up his day job in 1968 in order to concentrate on film and animation on a full-time basis. He became an apprentice in various commercial studios in New York, learning his craft the 'traditional' way, redrawing animator's roughs and creating 'inbetweens', but at the same time he was constantly formulating his own ideas and making plans for his own personal films.

Doing everything himself and overseeing the creative process from start to finish were key priorities for Griffin, and many of his films take the nature and process of animation as their starting point. This self-conscious questioning can be seen in many of his films, including *Trikfilm3* (1973), *Head* (1975) and *Viewmaster* (1976), each of which features a different style of drawing, photography and, often, Griffin himself. *Head* begins with Griffin addressing the camera to explain that, while his face shows the effects of age and life with a growing detail of lines and wrinkles, his drawings become ever simpler and more childlike. There follows an array of vignettes using a variety of styles, including photography, film and drawing.

A pivotal figure of New York's avant garde in the 1970s, Griffin did not restrict himself only to filmmaking but maintained an interest in all forms of artistic expression, creating animated flip-books to accompany each of his films. He also helped to establish gallery installations of animation art and was instrumental in putting together *Frames* (1978), a book celebrating independent animation artists from around the US. Having taught at Harvard (and presently at the Pratt Institute in New York), he remains unimpressed by the gap between the academic and the popular. 'I want to expand the agenda for the cartoon, a word whose root connotation of drawing or sketch has been seriously compromised by the saccharine, infantile, Disney sensibility,' he says. 'Animation should have its own avant-garde – an unapologetic, un-edited, not-for-primetime region, quite outside but somehow tethered to the mainstream.'

Griffin's more recent films are less fierce and perhaps more accessible, and he continues to work on commercial projects through his own studio, Metropolis Graphics. His personal work remains a passion, and all of his experiences feed into this. *New Fangled* (1992), for instance, is a hilarious if barbed jab at the advertising process, while *The Little Routine* (1994) is his affectionate homage to life with a family, again starring Griffin himself and also his daughter Nora.

Head (1975) contains George Griffin's homage to Emile Cohl and is the debut of his 'Square Guy' alter ego. Simple line drawings co-exist alongside photography and film to analyse the very nature of animation, a theme central to Griffin's work. Complex and deeply personal, *Head* distinctly expresses the painstaking yet magical nature of illusion.

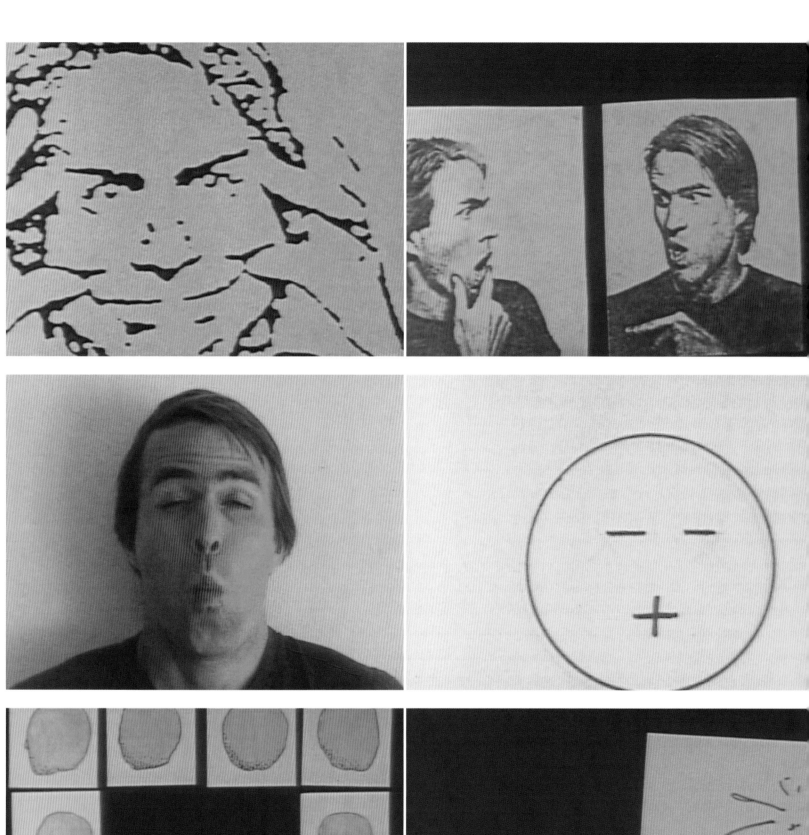

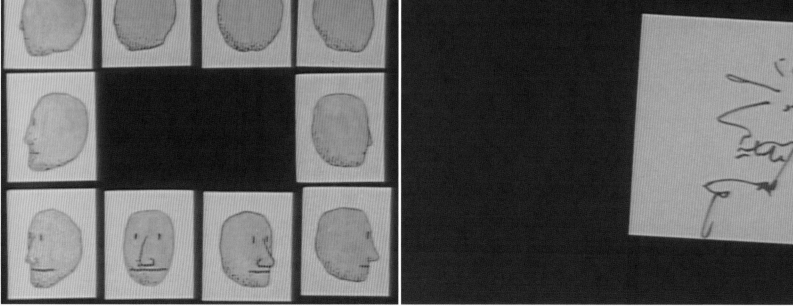

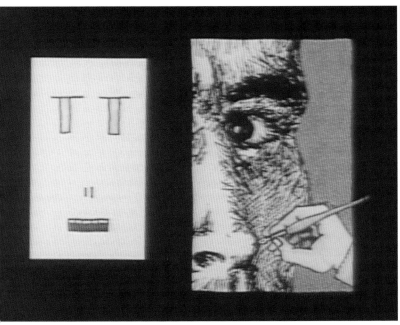

CAROLINE LEAF

TITLE
The Street

DIRECTION, DESIGN AND ANIMATION
Caroline Leaf

COUNTRY OF ORIGIN
Canada

VOICES
Mort Ransen, Vera Leitman, Howard Ryshpan, Sarah Hood, Dwight Hood, John Hood

SOUND EDITING
Gloria Demers

SOUND EFFECTS
Ken Page

RE-RECORDING
Michel Descombes

STUDIO ADMINISTRATORS
Signe Johansson, Louise Spence

PRODUCER
Guy Glover

EXECUTIVE PRODUCER
Wolf Koenig

PRODUCTION
© 1976 National Film Board of Canada

TECHNIQUE
Paint on glass

FORMAT
35mm, 16mm, Betacam SP, colour

LENGTH
10 minutes, 12 seconds

YEAR
1976

Born in Seattle in the US in 1946, Caroline Leaf studied visual arts at Radcliffe College, an affiliate of Harvard University. 'I was naïve about animation techniques, and took whatever was at hand and suited my needs,' she says of her decision to experiment with various techniques, such as spreading sand on to a piece of underlit white glass and manipulating it directly under the camera. 'In those days I was someone who felt she could not draw. Sand, as I started using it, was more like an object to push around on a lightbox than it was a drawing medium. I liked its limitations. I liked its infinite reusability.' Her first, student film, *Sand or Peter and the Wolf*, caused a sensation when it was first released in 1969 and convinced her to continue to innovate with animation.

In 1970 Harvard offered Leaf a Loeb fellowship to continue her studies there, but in 1972 she moved to Montreal to join the National Film Board (NFB) of Canada. '*Sand or Peter and the Wolf* opened doors for me,' she explains. 'Norman McLaren and other animators at the NFB saw it and liked it, and I was invited to do a sand animation at the Film Board, based on an Inuit legend, *The Owl Who Married a Goose*. Later, when I wanted to work with colour, I found a way to keep the gouache paints from drying, by adding a few drops of a medium like glycerine called Colorflex.'

The Owl Who Married a Goose (1974) and the later sand film *The Metamorphosis of Mr Samsa* (1977) won her a total of 21 awards as well as international acclaim. *The Street* (1976), which won 22 awards in its own right, was nominated for an Academy Award and was ranked second in the list of the world's 50 best animated films at the Olympic Arts Festival held in Los Angeles in 1984.

Consistently inspired by literature, many of her films are adaptations from short stories or legends from countries such as China or Mexico. Leaf works as designer and story adaptor on her films as well as animator and director, but she has not restricted herself to animation. She has also made live-action films and documentaries, including a profile of singer/songwriter sisters, *Kate and Anna McGarrigle* (1981). In 1986 she began to scratch directly into the soft emulsion of film, scratching into 70mm colour stock and then reshooting it on 35mm. *Two Sisters* (1990), which was created using this technique, won the award for best short film at that year's Annecy Animated Film Festival.

In 1991 Leaf left the NFB and decided to apply herself to painting on a full-time basis from her studio in Montreal. She returned to Harvard in 1996 to teach the same animation class she had herself once studied but then moved to London, UK, in 1998. She has also worked on several animated commercials, collaborating with production companies such as Pascal Blais Productions in Montreal and Acme Filmworks in Los Angeles.

Inspired by a short story by Montreal author, Mordecai Richler, **The Street** (1976) depicts a family's reactions to their dying grandmother. Caroline Leaf used paint on glass to show, in soft colours, how harsh and unfeeling families can be.

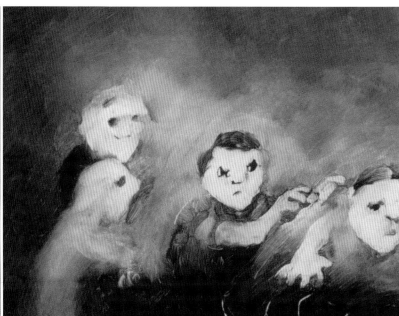

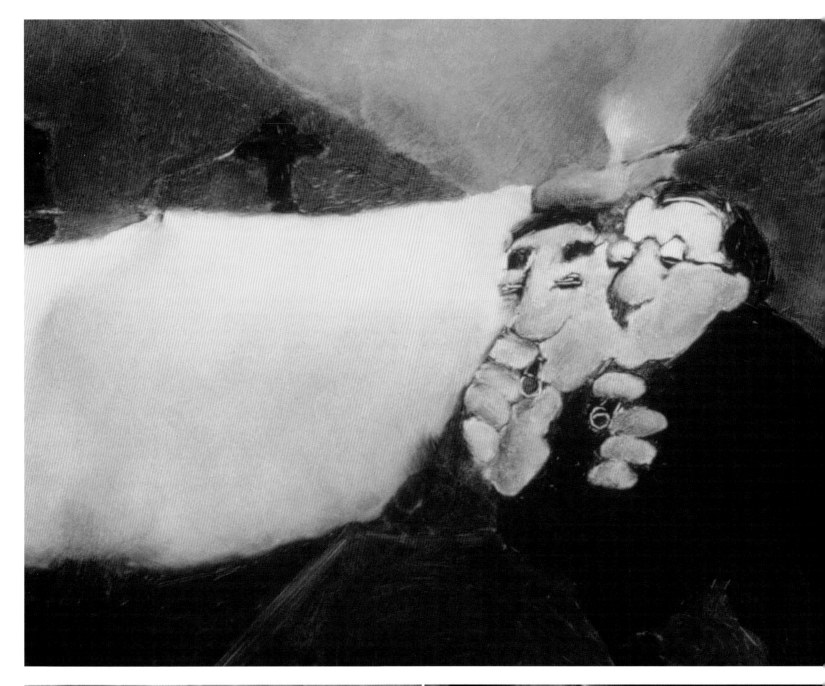

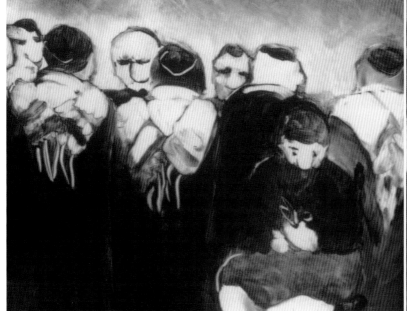

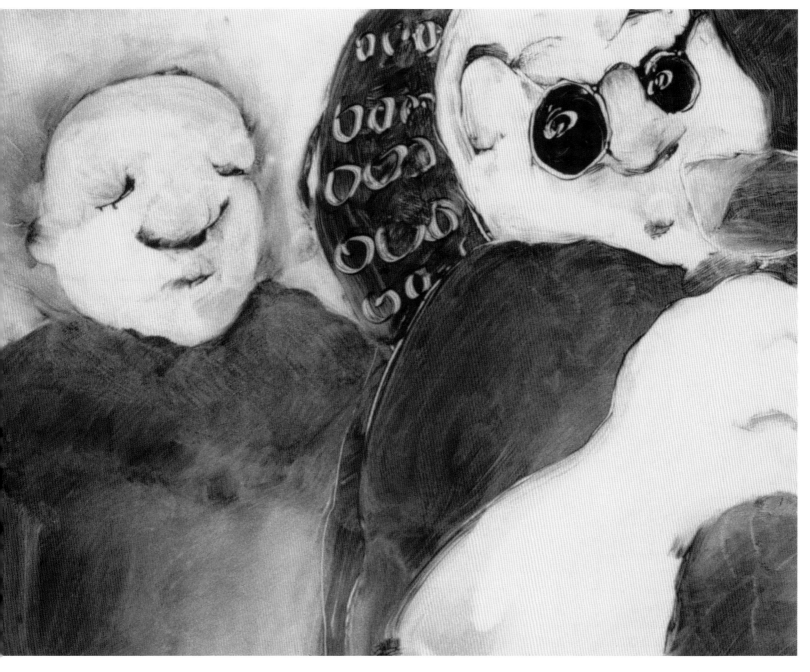

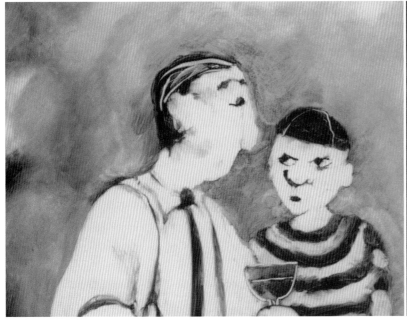

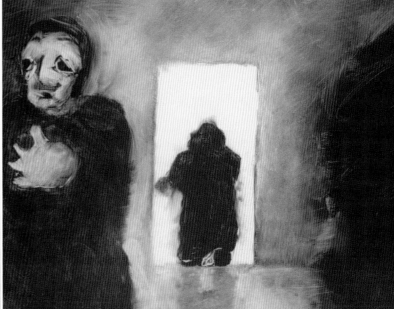

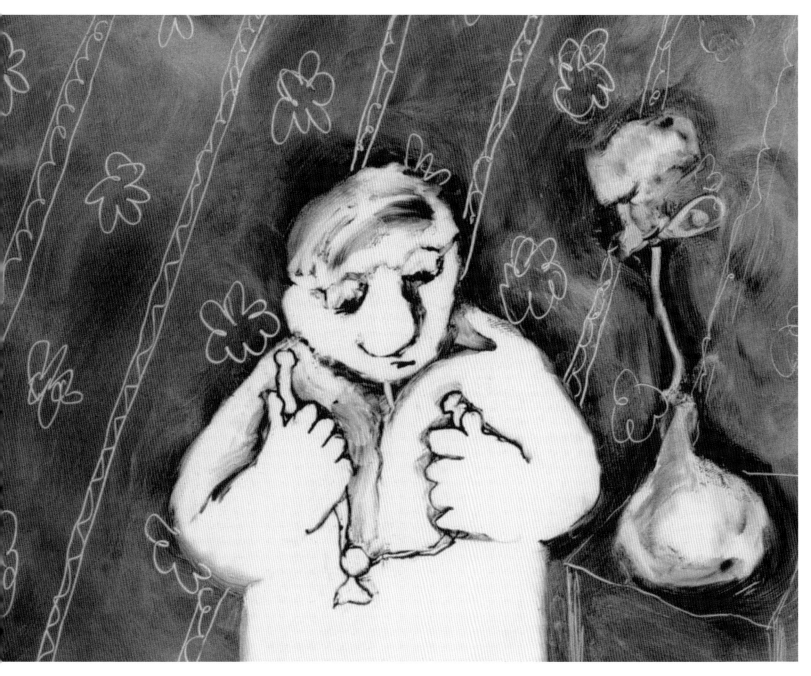

TITLE
Tale of Tales

DIRECTOR AND ANIMATOR
Y. Norstein

COUNTRY OF ORIGIN
USSR

PRODUCTION
Soyuzmultfilm Studio

STORY
L. Petrushevskaya, Y. Norstein

ART DIRECTOR
F. Yarbusova

DIRECTOR OF PHOTOGRAPHY
I. Skidan-Bosin

VOICE
A. Kaliagin

COMPOSER
M. Meyerovich

SOUND ENGINEER
B. Filchikov

MUSIC EXCERPTS
J.S Bach, W.A Mozart

FILM EDITOR
N. Trescheva

EDITOR
N. Abramova

HEAD OF PRODUCTION
G. Kovrov

TECHNIQUE
Drawn animation

FORMAT
35mm, colour

LENGTH
27 minutes

YEAR
1978

WEBSITE
www.jovefilm.com

114

Yuri Norstein is widely regarded as one of the most innovative animation directors of all time. Born in the village of Andreyevka in the Penza region of Russia in 1941, he was evacuated to Moscow in 1943.

Having studied at art school, Norstein initially worked in a furniture factory, before embarking on a two-year course attached to the state animation studio, Soyuzmultfilm, where he began working full time in 1961. Norstein had not actually wanted to work at the studio, being uninterested in the type of cartoons being made there. However, while he was there he came across the films and writings of Sergei Eisenstein, which had a huge influence on him: from that moment on he wanted to be a director himself. He also met his future wife and creative partner, Francesca Yarbusova, with whom he later collaborated on many of his films.

Norstein worked as an animation artist on some 50 films, which were directed by important figures, such as Fedor Khitruk and Ivan Ivanov-Vano. He directed his first film in 1967, the little known *25th: The First Day*, which included references to his other passion, avant-garde painting from 1910–20. 'The painters of that period enabled me to see the immense artistic potential of animation,' he explains. 'To sense the new graphic aesthetic. Through this project I discovered that animation is plastic time. This film influenced all my subsequent work. And I learned another lesson from this film: never make a concession if it goes against your conscience.'

Norstein certainly kept his word, running into trouble with the authorities on numerous occasions over the years. Together with his wife and his other regular collaborator, cameraman Alexander Zhukovsky, he invented a machine that allowed them to animate on layers of glass. His next film, *Heron and Crane* (1973), was based on a Russian fairytale: it was originally banned by the censors but was eventually released after much lobbying from Fedor Khitruk. His next film, *Hedgehog in the Fog* (1975), also ran into trouble when Norstein fell behind schedule: on the day he was meant to submit the film, only 20 per cent was finished. But Norstein showed what he had completed to the Communist Party meeting that was meant to censure him; they were so impressed that they allowed him to carry on and finish the film.

Tale of Tales (1978), which is widely regarded as Norstein's masterpiece, is the result of his third collaboration with Yarbusova and Zhukovsky. It is based on photographs of houses and old cars in the Moscow neighborhood where Norstein grew up. The film was initially rejected by nervous censors who forced him to rename it; the original title had been *There Will Come a Little Grey Wolf*. The new title, *Tale of Tales*, was a phrase from a Turkish poem written by Nazim Hikmet that Norstein happened to like and that he proposed to the censors on the spur of the moment. In 1984 it was named the best animated film ever made at the Los Angeles Olympic Arts Festival. In 1995 he was given the Russian Independent Triumph Award, which acknowledges the 'highest achievements in art and literature'.

Tale of Tales (1978) was a collaboration between director Yuri Norstein and the playwright Ludmilla Petrushevskaya. Based on Norstein's childhood memories, the film is exquisitely detailed and fantastically complex.

TITLE
The Sum of Them

PRODUCER, DIRECTOR AND ANIMATOR
Christine Panushka

COUNTRY OF ORIGIN
USA

TECHNIQUE
India ink and alcohol markers
on paper

FORMAT
16mm, colour

LENGTH
4 minutes, 30 seconds

YEAR
1984

Christine Panushka was born in Salt Lake City, Utah, in 1955, moving to Los Angeles in 1977 and studying at the California Institute of the Arts (CalArts) between 1980 and 1983. She taught at CalArts until 1997, by which time she had been appointed Associate Director of Experimental Animation. On leaving this post, she took up her current position of Professor/Chair of the Division of Animation and Digital Arts at the School of Cinema-Television, University of Southern California.

As well as teaching, Panushka has made short films, web projects, installations and is also an exhibited artist. She began studying visual art in Utah, where there was a 'tiny filmmaking programme' to which Panushka found herself inexplicably drawn. She made her first film, *Night's Last Child*, in 1977. That film started her 'obsession with the characters' that are present in much of her work, including her paintings. It was also the beginning of her exploration of the expression of 'inner states of being on film'.

Panushka uses animation as an extension of everything she does, be it installations or paintings. Her films also explore form and what she describes as the 'possibilities of non-narrative structure in a linear format such as film'. Her critically acclaimed graduation film from CalArts, *The Sum of Them* (1984), featured a series of large drawings of women. It was not put together using storyboards but simply tweaked in edit until she was satisfied. She used a similar technique to create her third film, *Nighttime Fears and Fantasies: A Bedtime Tale for a Young Girl* (1985), which she put together like a puzzle. Her challenge was to think about how the viewer could move from one piece to another.

Her mentor at CalArts, Jules Engel, commented that she should not be disheartened if people 'didn't want to see the movie', but *The Sum of Them* received great critical acclaim and won many awards worldwide. However, the edge was taken off her success when she was called in to show the film to a television studio. She 'naïvely' left the tape with them, and station identification clips were made that copied her work, thus forcing her to abandon other projects in the same style.

Panushka was named an Absolut Visionary in 1996: she conceptualized, directed and curated *Absolut Panushka*, the second issue in a series of content-based websites sponsored by Absolut vodka. *Absolut Panushka* was a groundbreaking website, which supported and promoted experimental animation and which highlighted the work of 24 world-class animators, including Panushka herself. 'The site gave experimental animation a venue,' she comments. 'It also brought to a new generation of artists the legacy of the past.'

Panushka still believes that the Internet is an excellent forum for experimental animation, giving people the ability to access animation without having to leave home. She is currently working on another web project, sponsored by Intel, called Ivy Basket (www.ivybasket.org). The Internet allows Panushka to combine her loves of non-linear user exploration and animation.

The Sum of Them (1984) features simply-drawn portraits of women who casually stare at the viewer. Their images are intercut with words such as 'gait' or 'flank'. Over the images are familiar sounds, such as running water and chirping birds. All the portraits eventually come together in one composition: the result is a delicate word/sound poem.

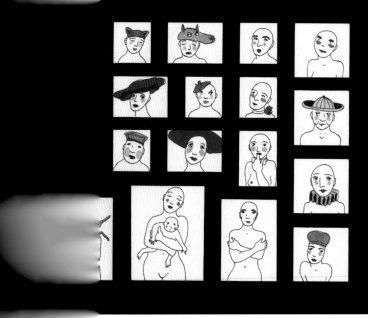

FRÉDÉRIC BACK

TITLE
The Man who Planted Trees

SCENARIO AND ANIMATION
Frédéric Back

COUNTRY OF ORIGIN
Canada

EXECUTIVE PRODUCER
Hubert Tison

PRODUCERS
Frédéric Back, A Société Radio-Canada Production

NARRATIVE
Jean Giono

ASSISTANT
Lina Gagnon

BACKGROUND SOUND AND ORIGINAL MUSIC
Normand Roger

ASSISTED BY
Denis L. Chartrand

SOUND PICKUP
Hervé J. Bibeau

MIXING
Michel Descombes,
André Gagnon

ANIMATION CAMERA
Claude Lapierre, Jean Robillard

EDITING
Normand Pickering

QUALITY CONTROL
Léo Faucher

TECHNIQUE
Pencil on frosted acetate

FORMAT
35mm, colour

LENGTH
30 minutes

YEAR
1987

Frédéric Back was born in 1924 in the German city of Saarbrücken. He has lived in Strasbourg, Paris and Rennes but has been based in Montreal, Canada, since 1948. Between 1938 and 1939 he studied printmaking and design at the École Estienne, Paris, and from 1939 until 1944 he attended the École des Beaux-Arts in Rennes, Brittany. His studies there under the celebrated Breton artist Mathurin Meheut were excellent training for a career in animation, and the young Back was taught all kinds of creative disciplines, including illustration, ceramics, painting, sketching, composition and engraving. Back comments: 'All of Meheut's work depicts very dramatically the activities of humans and animals. Of all the things I learned with him, sketching from nature was the main occupation, without knowing that one day I would have the opportunity to use it all in my animation.'

Back moved to Montreal in 1948 to teach painting and illustration in the Schools of Fine Arts and Interior Design. He became involved with the French television network Radio-Canada Television in 1952, and this gave him the opportunity to work on illustration, set design, scale models and sometimes animation. From 1968 Radio-Canada's animation studio was run by Hubert Tison: 'Tison was a talented and well-knowing animator,' says Back. 'He helped me a lot in every aspect of the art of animation.'

Back's work contains enduring themes such as ecology, peaceful behaviour and responsible, working people, elements that have always been important inspirations for him. 'I was always engaged with groups working for the protection of animals, nature and freedom. I ... found that animation was able to give me the tools to promote these objectives – much of my work aims to achieve this.'

During the 1970s Back made many award-winning films, although it was his Academy Award nomination for *All Nothing* in 1981 and then the Oscar for *Crac!* in 1982 that gave him the confidence to submit a proposal for *The Man who Planted Trees*, which went on to win some 40 awards as well as the Oscar for Best Animated Film in 1988. 'I had planted many thousands of trees when I discovered the story by Jean Giono. It was a privilege to work on such a rich and profound tale that has a biblical message of hope and of generosity,' Back says. 'The film has inspired many tree-planting initiatives in different countries.'

It was this ability to influence the world through his animated films that inspired Back to make his most recent film, *The Mighty River* (1993). He was hoping that what he had done for trees he could also do for water, 'essential for the perpetuation of life and beauty'. To date, *The Mighty River* has received some 20 awards. It was the grand prize-winner at the International Animated Film Festival held in Annecy, France, in June 1993 and it was also nominated for an Academy Award in 1993.

The Man who Planted Trees (1987) tells the story of a reclusive shepherd Elzeard Bouffier who, in a remote and desolate part of France, planted 100 acorns a day. Over time, this created an immense forest where once there had been nothing, bringing back water, life and people into a renewed environment.

STUART HILTON

TITLE
Save Me

DIRECTOR
Stuart Hilton

COUNTRY OF ORIGIN
UK

CONTRIBUTORS
Mark Shepherd, Molly Okell,
Michèle Smith, John Parry,
Sarah Cox, Jonathan Hodgson,
Damian Gascoigne, Sharon
Smith

PRODUCERS
Channel 4/The Arts Council, UK

TECHNIQUE
Hand-drawn, mixed media
live action

FORMAT
35mm, colour

LENGTH
6 minutes

YEAR
1994

WEBSITE
www.soreel.6.uk

'I wanted to do sculpture or painting or architecture until I visited Liverpool Polytechnic [now John Moores University] in 1984 and saw Jonathan Hodgson's *Nightclub* film and thought, "that's what I want to do",' explains Stuart Hilton. 'It was lively and raw and didn't look like anything I'd seen before. He did all the sound and pictures himself and that appealed to me too. I since joined his band playing drums and never left.'

Born in 1965 in Preston, Lancashire, Hilton graduated with a degree in graphic design from Liverpool Polytechnic and then studied for a masters degree in Animation from the Royal College of Art. In 1992 he produced *Argument in a Superstore* with the help of an award from the Arts Council. This was followed by *Save Me* in 1994, an animation made up of messages, scribbles and sound. Sound and music are integral parts of all of Hilton's work: 'Sound in my films helps to make the seemingly abstract imagery begin to operate symbolically and almost by accident hint at a loose narrative and drama,' he says. 'It gives the images a tangible reference. The space between what you see and what you hear is full of possibilities. As a musician myself there is a danger of pointlessly wrapping films up in music which is inappropriate and diverting. Music has its own unique history and complex set of associations that should be used with great caution.'

Hilton remains resolutely uninterested in using animation to try to create some kind of new world: 'This means trying to avoid infusing drawn motion with a sense of "magical life" or the dreaded curse of anthropomorphism,' he says firmly. 'Ultimately, I want to avoid making new worlds and to make new views of this one. I want any drawn line or smear or dot to appear to move and hence generate space only as a by-product of tracing, not as a result of me willing it to behave as if it were alive with a will of its own.'

Magpie-like, Hilton often steals drawings from games of Pictionary® to use as a starting point for his films. 'These are urgent, panicky, raw and artless remnants of communication that seem pregnant with meaning and are often unintelligible and cryptic,' Hilton says happily. 'Other sources are found lying around the studio on somebody's desk. Still other sources are filmed and refilmed either by me or stolen from TV. These sources are necessarily hidden in hugely convoluted ways, such as photocopied printouts mounted and filmed on a rostrum or polaroid photographs split in two and their back surface filmed.'

In 2000 Hilton and Ian Cross set up So, the graphics and live-action division of the London animation production company, Picasso Pictures. He has made advertisements for clients including Guinness and Orange and designed title sequences for films such as *Snatch*. Personal films remain a focus, however: 'For me, personal work has to be absolutely with no compromise. That's the joy of it, just trying to do something that I think looks right without having to check with anyone else that they like it. You just have to trust yourself, which can be difficult when you're working commercially most of the time.' And, of course, he continues to make music with his band, Cottonmouth, for whom he also designs record sleeves and videos.

Though Stuart Hilton creates seemingly abstract, non-linear films, **Save Me** (1994) does contain a loose episodic structure. 'The key feeling I'm trying to evoke is one of having missed something,' Hilton explains. 'It's about having to filter meaningless, important, dangerous, trivial and redundant information through our partially disengaged perception.'

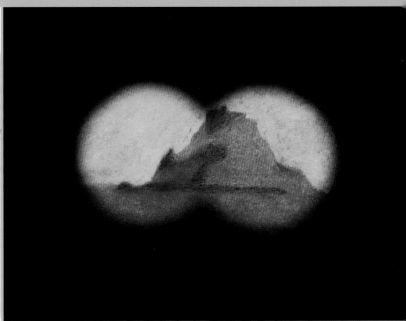

save me

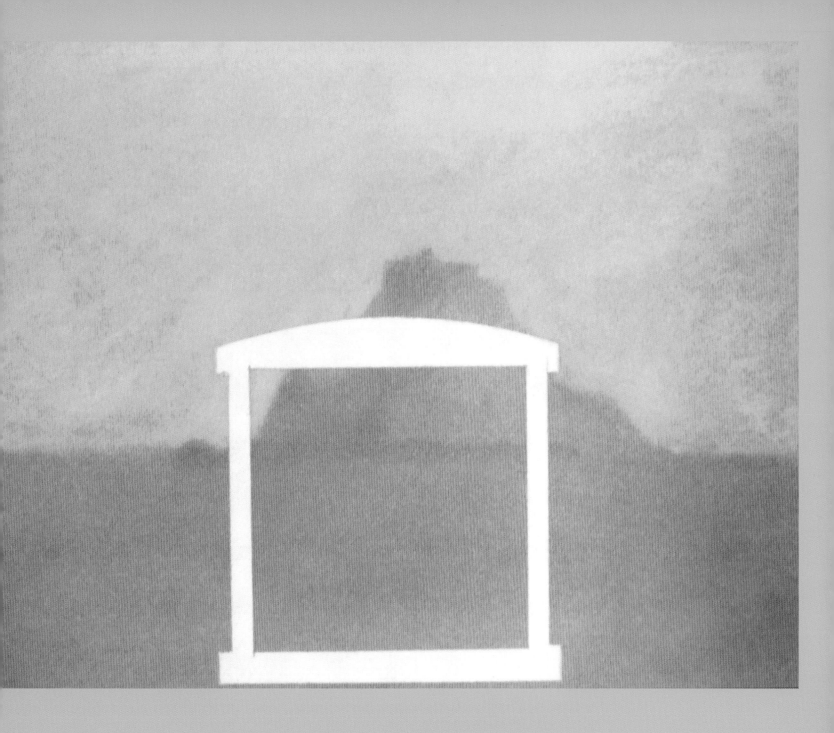

PHILIP HUNT

TITLE
Ah Pook is Here

DIRECTION AND ANIMATION
Philip Hunt

COUNTRY OF ORIGIN
UK

PRODUCER
Eddel Beck

PRODUCTION COMPANY
Filmakademie Baden-Württemberg

AUTHOR AND NARRATOR
William S. Burroughs

LIGHTING CAMERA
Philippe Timme

SOUND
©1990 Island Records Ltd.

MUSIC
John Cale

SOUND PRODUCTION
Hal Wilner

FINANCED BY
Mercedes Benz Kulturfoderung

TECHNIQUE
Stop-motion animation

FORMAT
35mm, colour and black & white

LENGTH
6 minutes

YEAR
1994

WEBSITE
www.studioaka.co.uk

Born in Bidford-on-Avon, UK, in 1966, Philip Hunt initially studied sculpture and graphic design before beginning to experiment with animation. 'I was introduced to animation as a child by programmes like *Vision On, Mary, Mungo and Midge* and *The Clangers* on TV,' he explains – and as an adult by animators as diverse as Joan Ashworth, Jan Svankmajer, Jiri Trnka and Hayao Miyazaki. 'Then terminal shyness and awkward teenage years led to an inevitable experimentation with animation. Also because I could not face being a vet, which was the original plan.'

The animal kingdom's loss is the animation industry's gain. After studying graphic design at Central Saint Martin's College of Art and Design and animation at the Royal College of Art in London, Hunt won the award for best film at the 1992 Stuttgart Animation Festival. His prize was to spend a year as the resident filmmaker at the Filmakademie Baden-Württemberg in south-west Germany, where he made *Ah Pook is Here* (1994), an elaborate, surreal homage to cult author William S. Burroughs.

'I was just so interested in his work,' Hunt says of Burroughs. 'Not so much even his written work alone, but most especially his performance of his works, his reinterpretations of his existing work and his mesmerizing voice. The idea to combine three unrelated texts into one narrative was inspired by Burroughs's own onstage "remixes" of his work.' Hunt is adamant that viewers should simply sit back and enjoy the film. 'People feel they ought to be impressed with the text or intimidated by it, but in fact if you listen to it Burroughs has a very plain poetic to his prose and delivery,' he says. 'I tried not to overpower this, even if it is some kind of demented chicken man sitting in a tree. In fact, my favourite reaction was in fact an introduction … The announcer at Annecy misread the title and warmly announced the next film as "Ah! Pooch is Home." I think she expected a comedy dog.'

Having travelled and worked all over the world, Hunt returned to London in 1996, eventually becoming creative director of the commercial animation studio, Studio AKA. There he has worked on numerous award-winning advertising campaigns for companies such as Compaq, Fifa and Orange, and he is careful to ensure that the agency maintains a reputation for producing innovative, edgy work. 'I hate a steady plod through life, I like to avoid doing what I've done before [and] to get up the nose of the shuffling old school,' he says firmly. 'A lot of fine art animators seem to make the same experiments over and over again. I am constantly being given a creative kick by directors like Shynola and Jakob Schuh, not to mention the other directors at Studio AKA, who surprise me all the time. While my mortgage inspires me to stay in advertising, my child inspires me with the mission to leave something else behind as well.'

Ah Pook is Here (1994) is an animated stream of consciousness, narrated by cult author William S. Burroughs. Split into three sections, the first contains a lament for the ghosts of some long-departed gods and the second the nihilistic ramblings of the central character, Ah Pook. The film concludes with Ah Pook's realization that suicide is his only answer.

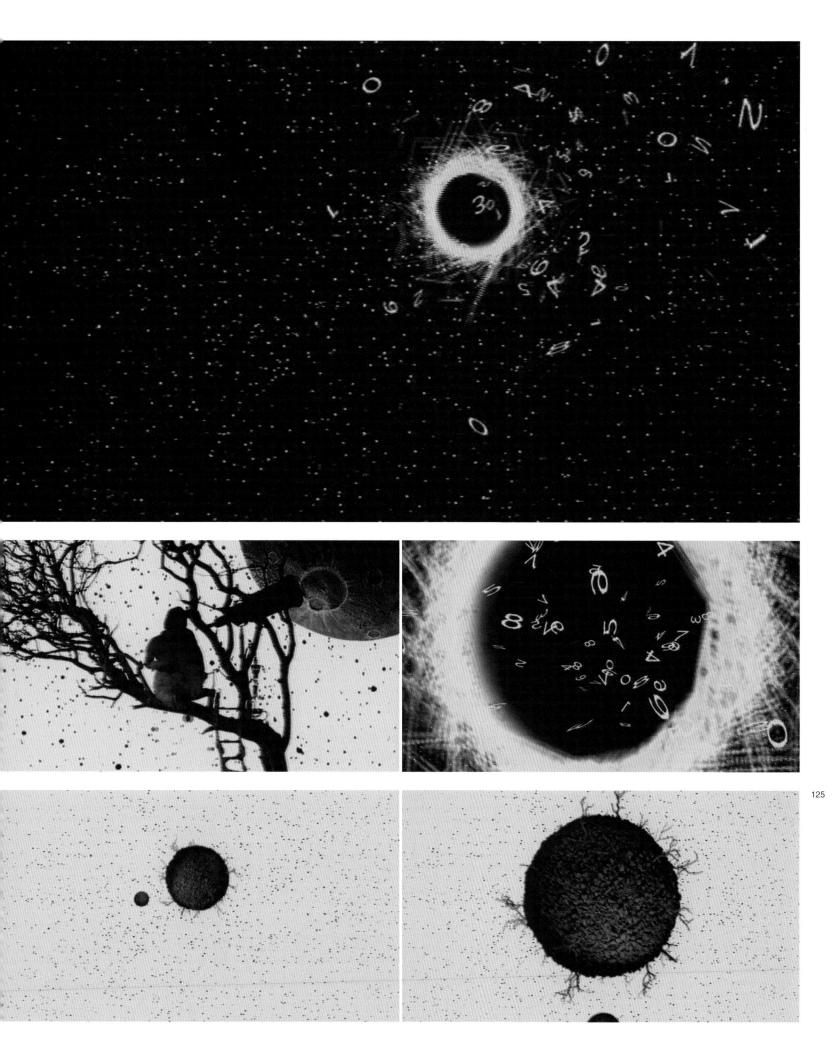

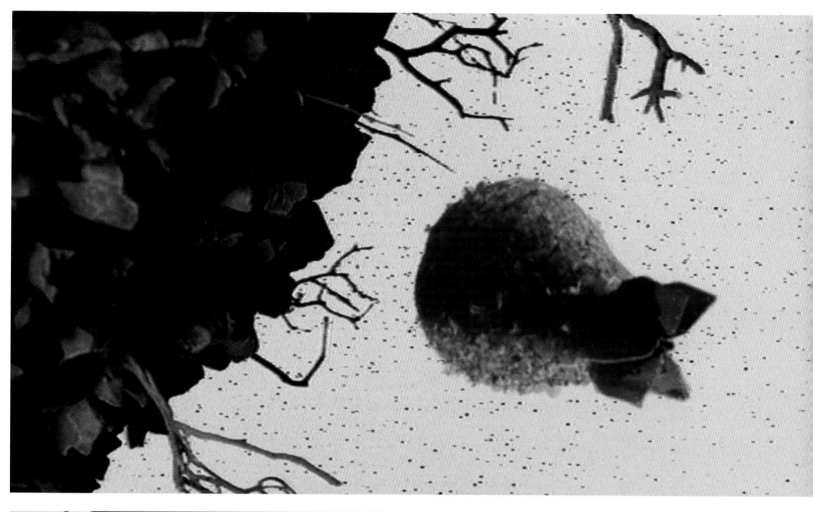

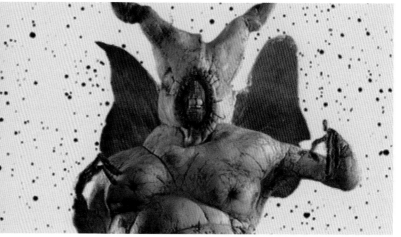
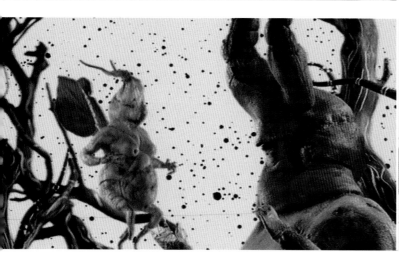
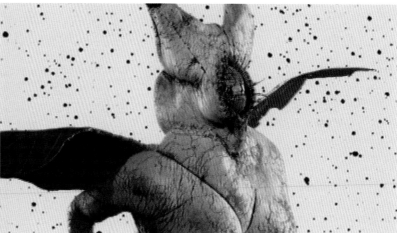

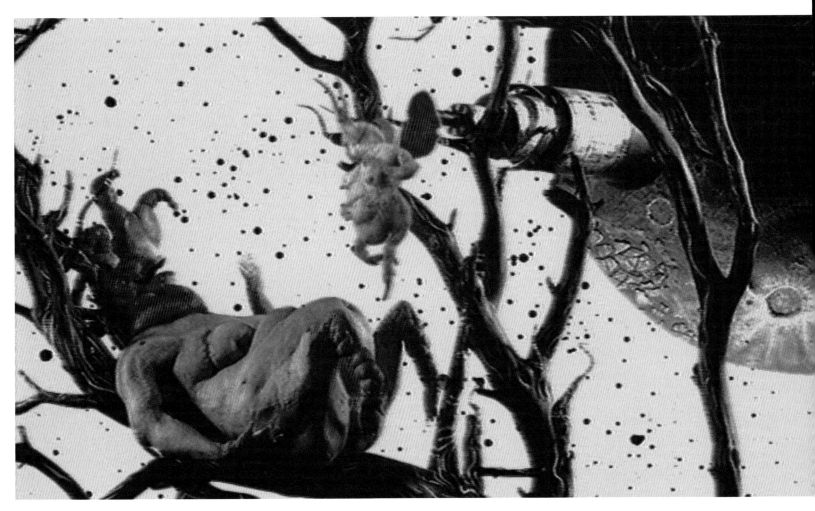

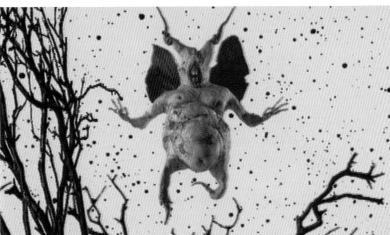

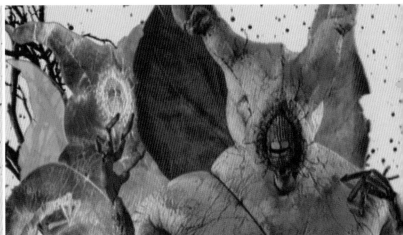

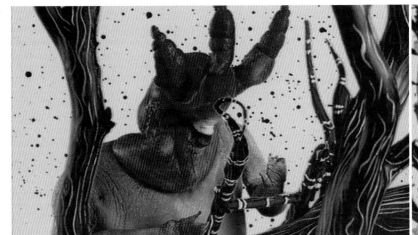

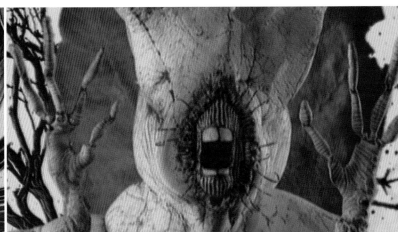

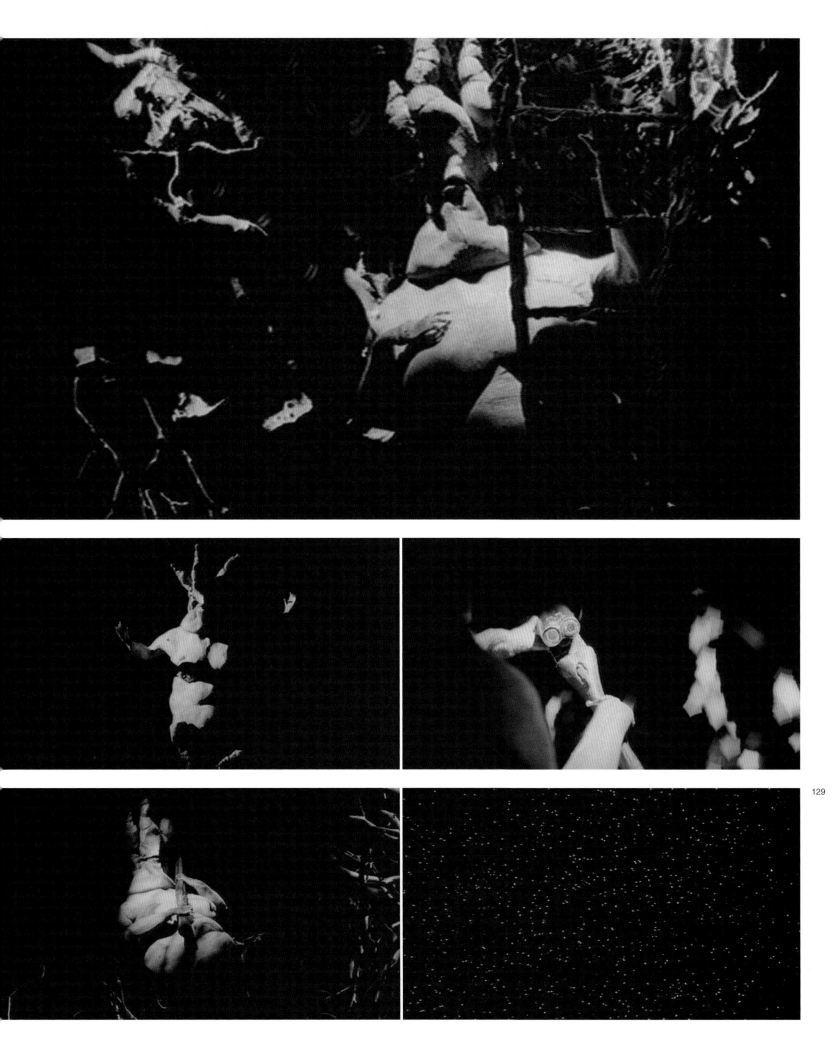

TITLE
The End of the World in Four Seasons

DIRECTOR
Paul Driessen

COUNTRY OF ORIGIN
Canada

COMPUTER IMAGERY, COMPOSITING AND COLLABORATION
Marie Renaud

PRODUCTION, COMPUTER PRODUCTION, DESIGN AND COLLABORATION
Marcy Page

EXECUTIVE PRODUCER
Barry Angus McLean

PRODUCTION
© 1995 National Film Board of Canada, in association with La Sept Arte

MUSIC
Normand Roger, based on Vivaldi's *Four Seasons*

RE-RECORDING
Serge Boivin, Jean-Paul Vialard

TECHNIQUE
Computer animation

FORMAT
35mm, 16mm, Betacam SP, colour

LENGTH
12 minutes, 57 seconds

YEAR
1995

Paul Driessen is one of a rare breed of experimental animators: he has managed to make his living almost exclusively from his short films. Born in Nijmegen, Holland, in 1940, he studied at the Academy of Arts where he worked mainly in cartoon illustration, which was followed by his own experimentations in animation. He began animating television commercials in 1964, and in 1967 he was invited to England to work on George Dunning's animated Beatles' film, *Yellow Submarine*, which he did for a year.

Driessen attributes much of his success as an animator to several happy coincidences, the most significant being his own dual nationality: as the owner of both Canadian and Dutch passports he has been able to work on funded productions in both countries. He began working at the ever-influential National Film Board (NFB) of Canada in 1970. His contract with them enabled him to make any film he liked, while the NFB would keep the films' rights, an arrangement that continues today. He has also been able to direct many other films for Dutch independent producers.

Driessen's characteristically simple style allows him to work quickly, often on two productions at the same time, while his work for the NFB has allowed him to explore his core subject, the narrative form. A self-confessed storyteller who does not use words, he says: 'I experiment with storytelling but I see how much you can do with the screen.' As part of his experimentation into narrative within film he often works with split screens so that the viewer follows more than one story at a time, and each may meet in the middle, the end or even only at the beginning. Always using interconnected imagery and themes, his main concern is to provide a 'careful balance between the storytelling and too much information – how do you direct an audience with a complex tale?'

During the course of his career Driessen has made more than 20 award-winning films in Canada, Holland and elsewhere. His film *3 Misses* (produced by Willem Thijssen of CinéTé), earned him an Academy Award nomination in 1999. His most recent film, *The Boy Who Saw the Iceberg*, was released in 2000. He is currently working on the animated web project *2D or Not 2D*, a co-production with CinéTé and the NFB. Arte France and Channel 4 are also involved in the project.

Driessen has taught animation at the University of Kassel in Germany since 1988, something he professes to enjoy immensely and which allows him to commute more regularly to Europe. Some of his students have even acquired Academy Awards themselves, notably Thomas Stellmach and Tyron Montgomery for their 1997 film *Quest*.

Paul Driessen uses eight different screens in **The End of the World in Four Seasons** (1995). Each season is illustrated through archetypal situations: in Autumn for example, a snake chases a frog, while in Summer a mosquito plagues a tourist. All these scenes take place within the different panels, and at the end of each season the panels interfere with each other and the world is destroyed.

TITLE
The Albatross

DIRECTOR
Paul Bush

COUNTRY OF ORIGIN
UK

STILLS
Paul Bush

PRODUCTION
Paul Bush/Ancient Mariner
Productions

VOICE OF THE MARINER
Gerard Murphy

FACE OF THE MARINER
Julian Maynard Smith

MUSIC
Geoffrey Bush

SOUND
Andy Cowton

TECHNIQUE
Scratching on film

FORMAT
35mm, colour

LENGTH
15 minutes

YEAR
1998

Paul Bush doesn't actually consider himself to be an animator. Instead, he describes himself as a filmmaker. Following in the footsteps of Len Lye, Stan Brakhage and other such pioneers, he scratches directly into filmstock to create his works. 'I'm not so interested in the graphic aspect of animation but I am fascinated by the photographic aspect of film,' he explains. 'My scratching technique does look very graphic, but you can also see the photographic basis of the film. It's very important for me to work with proper photographic images.'

Born in London in 1956, Bush initially studied fine art at Goldsmiths College, University of London, but although fine art does have an influence on his work, he is insistent that he is not an artist per se. 'I don't think of myself as an artist,' he says. 'For me, film is a different milieu to the art world. Fine art is sold for a large amount of money but seen by only a few; with film I can have a huge audience and that is a really important consideration for me.'

Bush did spend two days creating some basic animations while he was on an art foundation course when he was 18, but he began to make films in 1978 after joining the London Filmmakers Co-operative. 'Things really happened by chance, I learned things along the way,' he says of his first experiments. 'In 1981 I started teaching filmmaking part time at the Clapham and Battersea Institute, and the first class I taught was on how to make a film without equipment, so we began playing around with film on its own terms. I was always very challenged by my students in the class and was able to develop my own film practice over a period of about ten years.'

Having made a number of experimental films, including *The Cow's Drama* (1984), *So Many, So Magnificent* (1987) and *Lake of Dreams* (1992), Bush turned to engravings and illustrations for inspiration in his next films. *His Comedy* (1994) used Gustav Doré's illustrations for Dante's *The Divine Comedy* as its starting point, while *Still Life with Small Cup* (1995) is based on an etching by the Italian painter Giorgio Morandi. Both of these films were created by scratching directly on to the filmstock, as was the epic *The Albatross* (1998), which took two years to complete. 'Of course, nowadays it would probably be more economical to do it on a computer,' he says. 'But I don't do that because of a sense of purism and because if you've got a sense of the way that something should be carried out, you should carry on doing it that way.'

Bush also makes commercials through London animation production company, Picasso Pictures. 'I spent one year making two commercials for Japan,' he says unrepentantly. 'Yes, you're often asked to rip off yourself or somebody else, but advertising creatives work very hard to find new ways of selling things. It is parasitic but I enjoy it!'

Taking 30 verses from *The Rime of the Ancient Mariner* by Samuel Taylor Coleridge as its starting point, **The Albatross** (1998) also samples 19th-century engravings and sea shanties. The images were photographed and then the filmstock was scratched by hand.

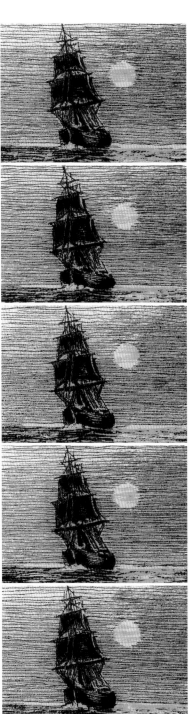
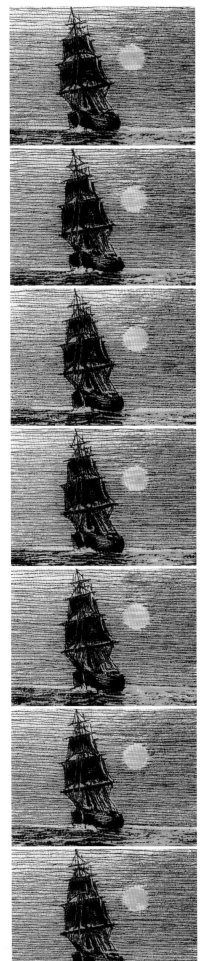

138

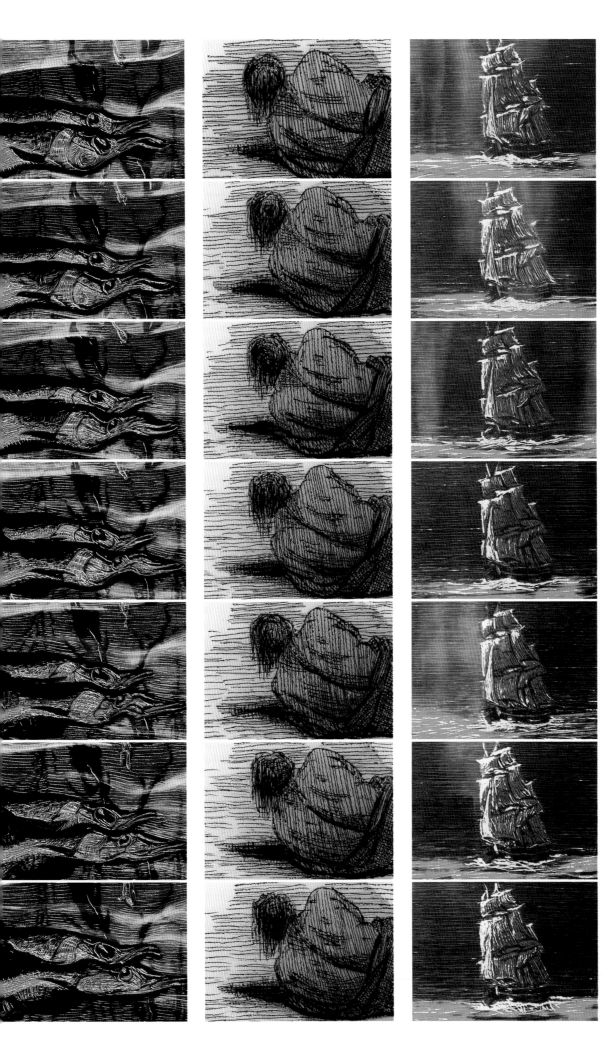

JONATHAN HODGSON

TITLE
The Man with the Beautiful Eyes

DIRECTION, CINEMATOGRAPHY, EDITING AND SOUND DESIGN
Jonathan Hodgson

COUNTRY OF ORIGIN
UK

PRODUCER
Jonathan Bairstow

DESIGNER
Jonny Hannah

FUNDING
Channel 4 TV

AUTHOR
Charles Bukowski

VOICEOVER
Peter Blegvad, Louis Schendler

PRODUCTION COMPANY
Sherbet

ANIMATORS
Jonathan Hodgson, Kitty Taylor, Lucy Hudson

ASSISTANT ANIMATORS
Bunny Schendler, Martin Oliver

ARTWORKERS
Mark Shepherd, Jonny Hannah

ROSTRUM CAMERA
Peter Tupy

DRUM BREAK
Stuart Hilton

RECORDING
Liam Watson

TECHNIQUE
Ink and acrylic paint on watercolour paper

FORMAT
35mm, colour

LENGTH
5 minutes, 38 seconds

YEAR
2000

WEBSITE
www.sherbet.co.uk

140

Jonathan Hodgson was born in Oxford, UK, in 1960 and educated at Liverpool Polytechnic. 'I wasn't actually interested in animation,' he admits. 'I just wanted to transfer from Brighton University, where I was studying illustration, to Liverpool, because it seemed like a more exciting place to be. So I went through the system, pretended that I "really wanted" to do animation and somehow got on the course. But after about a year I began to see that there really was something in it and that maybe I might be able to make a living out of it. Then suddenly I realized that I couldn't see myself doing anything else. Animation became a total passion.'

By the time Hodgson left Liverpool in 1981 and the Royal College of Art in 1985, he had already made a number of short films, and he then formed a commercial partnership with fellow former student, Susan Young. 'I didn't have any intention of getting into commercials,' he says frankly. 'I couldn't possibly see anyone being interested in my work, but then pretty much everything that's happened to me has been by accident.'

Having co-founded commercial animation studio Bermuda Shorts in 1991, he went on to set up Sherbet with producer Jonathan Bairstow in 1996. 'We really set up Sherbet just because we had the opportunity to do so,' says Hodgson. 'We were offered a series of ads for Saab USA and so we needed a company, it was as simple as that. We thought that we should probably just fold it after the campaign was finished, but a few months went by and more work came in, then even more, and it grew from there.'

Hodgson has worked on advertising campaigns for clients including Bell Atlantic, Baltimore Aquarium and Persil, but he remains fascinated with short films. 'I don't want to slag off commercial work, I've learned a lot from it,' he says. 'But I still want as much freedom as possible, and making short films is the easiest way to have freedom. If you start making longer films then you have to raise the finance to make them and you have to work with large teams of people. I would prefer to go off with a video camera on my own and do it that way. I'm not desperate to make a feature film: it's so much work making a 6-minute film, I don't want to spend the rest of my life working on one thing.'

His films to date include *Feeling My Way* (1997), *The Man with the Beautiful Eyes* (2000) and *Camouflage* (2000), all featuring what he calls his 'bad animation'. 'I'm quite into "bad animation" or limited animation and bad drawing. I like children's drawings, teenagers' drawings, outsider art,' he confesses. 'Things that have been done without any consideration, things that have happened by accident interest me as much as any educated art.'

The Man with the Beautiful Eyes (2000) portrays some children who play in an overgrown garden. On one occasion, they see the man who lives there, viewing him in rather more romantic terms than their neurotic parents, who are horrified to discover that they have been there.

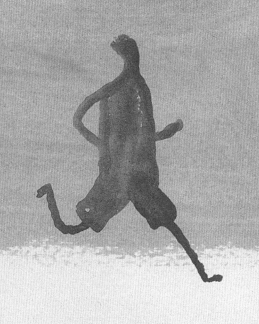

JUNE

blazed

having *A* good *T*ime,

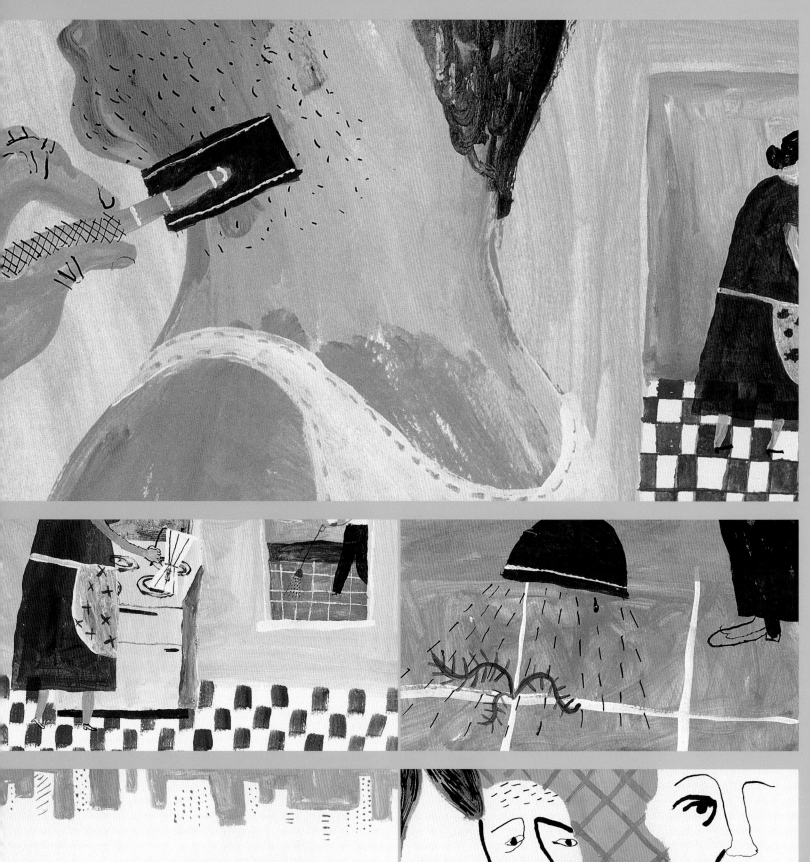

TITLE
Tales of Mere Existence:
Protégé

SCRIPT, DIRECTION, ANIMATION AND VOICEOVER
Lev Yilmaz

COUNTRY OF ORIGIN
USA

TECHNIQUE
Consumer grade 3 chip DV
camera, PC, Premiere

FORMAT
Mini DV

LENGTH
1 minute,10 seconds

YEAR
2000

WEBSITE
www.ingredientx.com

LEV YILMAZ

Lev Yilmaz was born in 1970 in Boston, Massachusetts. From an early age he made experimental, satirical films with his two brothers. Having studied video at the School of the Museum of Fine Arts, Boston, in the early 1990s, he relocated to San Francisco in 1998 to pursue a professional career in animation. Shortly afterwards he founded the website www.ingredientx.com to showcase his short film work. 'I started Ingredient X as soon as the HTML tools were easy enough for me to use so I could maintain it myself,' he says. 'In the mid-90s, if I wanted to show my work I'd have to lug a TV and VCR to coffee houses on open mic nights and hope the audience didn't leave before the poets were finished. By 1998–99 I had made a hell of a lot of material that had never seen the light of day.'

In 1999 Yilmaz created an experimental piece, which quickly blossomed into his working on an ever-growing series. Using a rudimentary animation technique, he created *Tales of Mere Existence*: charming, intimate, sometimes explicit, sometimes dark observations or confessions of real life, narrated by Yilmaz himself. The viewer is presented with a series of key drawings, which are embellished by an unseen hand as the narrative continues. Always resolutely lo-fi, the stories are nonetheless strangely compelling. 'I got the idea for the technique from a movie called *The Mystery Of Picasso* [1956], it's about as low budget animation as it gets,' Yilmaz explains happily. 'The idea was to tell these seemingly simple stories as matter-of-factly as I could. I still don't completely understand why they become funny, but I think you can approach them from a smart place or a dumb place and they still work.'

Using a DV camera and 'pretty basic' PC to create the films, Yilmaz calculates that most episodes take about two days to put together, while each film costs about $12 (£7) to produce. 'As any kind of artist, you can never have any idea if or when you may hit rock bottom. It's nice to know you can always make work regardless of your financial situation,' he says. 'The most time-consuming part is getting the script right. I usually record the audio first to make sure the story flows well. Around half of the drawings are first take, some shots I have to do as many as four times to get them right. This usually happens when I start getting obsessive and precious about the drawings, and I have to back off and relax for a minute and remember *Tales* is not the Sistine Chapel.'

'I think a lot of the reason the series works is that from the first frames, the audience knows I'm making no effort whatsoever to impress them with technique or technology,' he continues. 'It's like watching a sock puppet: your believability barriers come down and your imagination kicks in and makes the puppet become very alive. The audience then focuses almost entirely on the stories, which is what this series is all about to me anyway.'

Tales of Mere Existence: **Protégé** (2000) explains how our unidentified hero used to copy people he admired as he grew up. So he 'became' the skateboarder Mike, the metalhead Ken and Dave from art college before finally becoming himself. 'I suppose I kind of like the thought of just being myself, but I'm still afraid I'm going to find out I'm a dick,' he concludes wryly.

TITLE
The Future of Gaming

DIRECTION, DESIGN AND CONCEPT
Johnny Hardstaff

COUNTRY OF ORIGIN
UK

PRODUCER
John Payne, Black Dog Films

WRITING
Johnny Hardstaff and Chas Byfield

EDITOR
J.D. Smythe

SOUND DESIGN
Dain Williams and Johnny Hardstaff

ADDITIONAL MAC SUPPORT AND ILLUSTRATION
Chellie Carroll

FLAME AND POST-PRODUCTION
The Mill

SOUND
Mixing Wave

DOP
Ben Smithard

ADDITIONAL SOUND
Dain and Sam at Planet

ADDITIONAL DV PHOTOGRAPHY
Johnny Hardstaff

ADDITIONAL DESIGN SUPPORT
Paolo Giardi and Michelle Carroll

TECHNIQUE
Illustrator, Photoshop, DV, Flame

FORMAT
35mm, colour

LENGTH
5 minutes, 43 seconds

148

YEAR
2001

Johnny Hardstaff cheerfully admits that he spent much of his graphic design course at Central Saint Martin's College of Art and Design, London, avoiding print and instead making three-dimensional models: 'The main reason I felt deeply uncomfortable with print during my college education was that I felt it to be lacklustre and disappointing. Two-dimensional. Static. Ephemeral in the worst sense,' he explains. 'The excitement for me lies in seeing narrative and motion realized.' His experimentations in film and animation nonetheless retain a strong graphic feel, as he carefully combines graphics and architectural structures with live-action footage to offer a genuinely original vision.

Hardstaff remains an anarchic, unpredictable and uncompromising figure on the edge of the commercial creative industry. When asked to reveal when he was born he ignores the question entirely, replying instead: 'My favourite years are 1933, 1977 and 1989.' Signed to London production company Black Dog, he remains resolutely unimpressed by either his clients or his peers. 'I can't think of anyone whose computer graphics/animation work I actually admire,' he says seriously. 'I gravitate more towards inspirations from beyond the CG animation world. Peckinpah. Lucas. Gilliam. Kurosawa. Gilliam again. Jewison. Kubrick. Svankmajer. Borowczyk. Gibson. Nin. In the rather closed little backwater of CG animation, we're all little minnows. The admiration of bigger fish seems a little more relevant to me.'

He has, nevertheless, created some outstanding commercial work for bands such as Radiohead and Super Furry Animals, and clients remain keen to harness his talent. 'If commercial patronage enables you to do exactly what you wish without any interference, then why fight it?' he asks. 'It's self-initiated work paid for by others.' One such film is *The Future of Gaming* (2001), which was ostensibly created as a promotional film for Sony PlayStation 2 but which caused, as Hardstaff puts it, 'open mouths, dropped doughnuts, pins dropping, then complete silence' when executives there first saw it. No wonder, when the film features an increasingly frantic corporate head executive discussing how their company has 'toilet trained the developed world's consumers to shit in their own backyard', before acknowledging that all the marketing hype is just about 'a fucking games machine'.

'If "corporate" patronage allows you to produce an exceptionally anti-corporate film that subverts from within and generates internal corporate unease, then surely that's irresistible?' Hardstaff asks mischievously. 'The only danger is if the work becomes a cynical tool for someone else. Fortunately, Playstation found this film entirely unusable. They tried to play it at a live event on one occasion, but according to the press, it left the audience depressed and harrowed. How delightful is that?'

Corporate subversion aside, Hardstaff is currently developing a screenplay he has written for a long format project, though plans for the future remain fairly obscure. 'My ambitions and objectives change by the hour,' he admits. 'Inevitably though, a farmouse, a Jack Russell (they can run and run), the Peak District and a shotgun would suffice.'

The Future of Gaming (2001) features director Johnny Hardstaff's beautiful graphic sensibility together with his mischievous sense of humour. A promotional film – with a twist – the film features the increasingly frantic voiceover of a corporate head talking to her colleagues and subordinates.

'What is particularly interesting about animation is that the "cheat" is so blatant - we don't pretend that what you are seeing on screen isn't a drawing or a lump of Plasticine and yet the illusion can still be pulled off,' says animation director Mark Baker, whose film *The Hill Farm* (1988) features various different characters, all imbued with their own personalities. Although they communicate in an unrecognizable language, it is their characterization that makes them intelligible.

This chapter celebrates characters in animation, probably the most common and certainly the most widely accessible form of the medium. However, the characters featured here are not necessarily the cute anthropomorphic animals that turn up so regularly in most children's cartoons. The hero in Run Wrake's film *What is That* (2001), for example, is the appropriately named, very un-Disney character, Meathead. Borivoj Dovnikovic's film, *The Exciting Love Story* (1989), sounds more traditional in its approach to characterization on the surface, as it ostensibly tells the tale of Mickey and Gloria, but the film is more notable for Dovnikovic's experiments with the format.

CHARACTER

Harry Smith's beautiful abstract films, such as *Mirror Animations: Number 10* (1957, 1962–76) feature characters, but nonetheless explore complex themes referencing Buddhism and the Kabbalah. Characterization remains a perennial theme of interest for contemporary directors too, including Richard Kenworthy (*The Littlest Robo*, 1999) and John Lasseter (*Tin Toy*, 1988), as they develop new techniques and approaches for breathing life into computer-generated figures.

Many of the films in this chapter are dark, brooding and unsettling, and characters are the focus of this emotional expression: see, for example, Suzie Templeton's stop-motion *tour de force*, *Dog* (2001), in which unspoken heartbreak shines through both the father and son. Michael Dudok de Wit's achingly poignant and utterly beautiful, painterly *Father and Daughter* (2000), features characters who never speak, which was a deliberate decision for the director. 'I enjoy making films without

human voices,' Dudok de Wit explains. 'The accent and timbre of a voice conveys an abundance of subtle messages, and unless the visuals match those messages harmoniously, there can be a conflict,' he concludes.

Political statement has also found a natural outlet in characterization in some animation, as many directors created potentially subversive films, using characters to express a commentary on their society or a contemporary political situation. The confused status of the medium, standing as it does between mainstream cartoon and film, meant that censors often overlooked animation, perhaps more intent on monitoring live-action directors. Fedor Khitruk, Andrei Khrjanovsky and Nina Shorina used animation to comment on the Soviet regime in, respectively, *Story of One Crime* (1962), *There Lived Kozyavin* (1966) and *Door* (1986). Similarly, Jiri Trnka used his fantastic skill with puppets in *The Hand* (1965) to make a searing indictment of communist life in Czechoslovakia. More recently, Renzo and Sayoko Kinoshita used animation to comment on the increasing commercialism of Japanese society, in their film *Made in Japan* (1972).

TITLE
Mirror Animations: Number 10

DIRECTOR
Harry Smith

COUNTRY OF ORIGIN
USA

TECHNIQUE
Paper cut-outs, collage

FORMAT
16mm, colour

LENGTH
3 minutes, 35 seconds

YEAR
1957, 1962–76

WEBSITE
www.harrysmitharchives.com

HARRY SMITH

Harry Smith was born in Portland, Oregon, in 1923. His parents were Theosophists who encouraged him to explore and question aspects of religion from an early age. His mother taught in a school on the Lummi Indian reservation. By the time he was 15 years old Smith had begun to record the songs and rituals of the Lummi and Samish people and was compiling a dictionary of Puget Sound dialects.

Smith went to the University of Washington to study anthropology, and his subsequent body of work is derived to a great degree from various 'primitive arts'. However, in 1944, after attending a Woody Guthrie concert where he smoked cannabis for the first time, he dropped out of university. He concluded that the intellectual stimulation he craved was not to be found in the hallowed halls of academia, so he headed for San Francisco. It was there that Smith began to build up a reputation as a leading experimental filmmaker, frequently showing in the 'Art in Cinema' organized by Frank Stauffacher at the San Francisco Museum of Modern Art. He became close to other avant-garde filmmakers living in the Bay area and was also greatly interested in the works of Oskar Fischinger and other southern Californian experimentalists, travelling to Los Angeles to view their work.

Smith's own films cannot be easily separated from his paintings; he was a huge fan of non-objective art and the work of painters such as Wassily Kandinsky and Franz Marc. Like many experimental animators, he developed his own unique methods of animation, using stop-motion and collage techniques as well as painting and scratching directly on to the film – many of his films took years to complete. In them he explored the relationships of colour, sound and movement, and with their intriguing blend of rituals and iconography they are often acknowledged as the forerunners of 1960s psychedelia.

Smith did not limit himself to filmmaking: he retained his interest in anthropology and also studied music and languages, releasing his *Anthology of American Folk Music* in 1952. The result of many years of research, this had an acknowledged influence on up-and-coming artists such as Bob Dylan, and in 1991, Smith received the Chairman's Merit Award at the Grammys for his contribution to American folk music. He was also an avid collector of unusual objects: during his lifetime he collected thousands of Ukrainian painted Easter eggs and had written annotations about each one. He also donated his collection of paper aeroplanes to the Smithsonian Air and Space Museum in Washington.

Smith's interest in religion and the occult continued throughout his life and he spent his last few years as 'shaman in residence' at the Narpoa Institute. He died in the Chelsea Hotel in New York in 1991.

Harry Smith described his symbolic **Mirror Animations: Number 10** (1957, 1962–76) as 'an exposition of Buddhism and the Kabbalah in the form of a collage. The final scene shows agaric mushrooms growing on the moon while the hero and heroine row by on a cerebrum'.

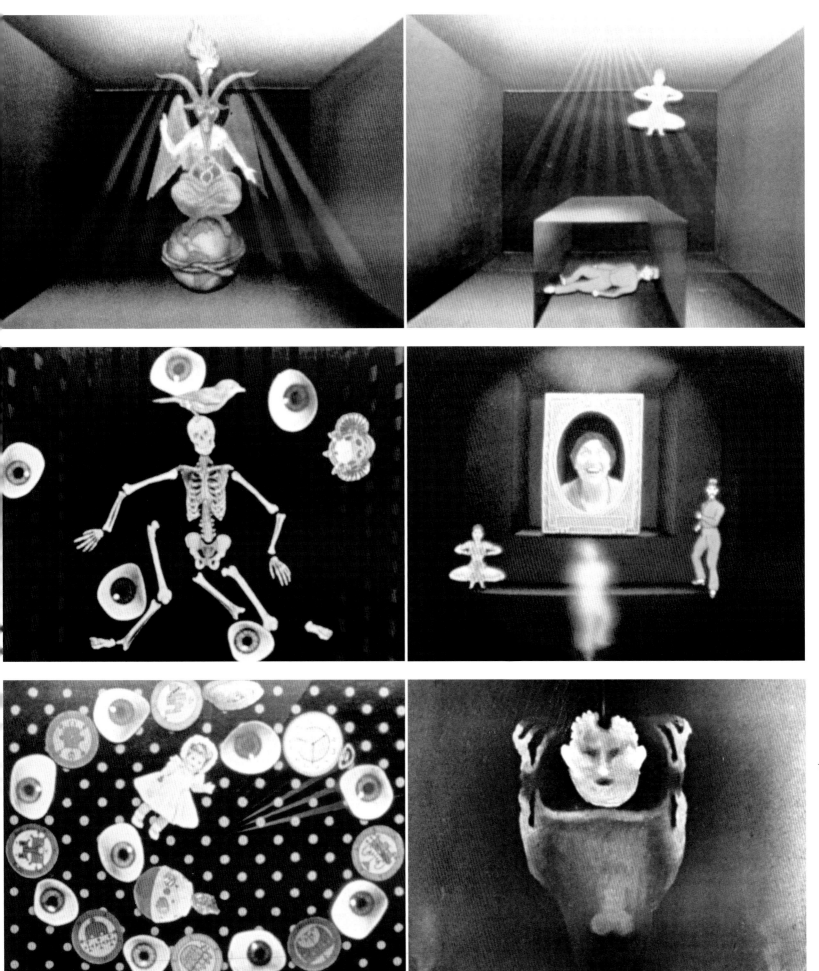

FEDOR KHITRUK

TITLE
Story of One Crime

DIRECTION
F. Khitruk

COUNTRY OF ORIGIN
USSR

PRODUCER
Soyuzmultfilm Studio

SCREENWRITER
M. Volpin

ART DIRECTOR
S. Alimov

COMPOSER
A. Babaev

CINEMATOGRAPHER
B. Kotov

SOUND DIRECTOR
G. Martinuk

EDITOR
P. Frolov

PRODUCER
L. Senatorova

ASSISTANT DIRECTOR
G. Brodskaya, M. Rusanova

CAMERAMAN
M. Kuritsina

DECORATORS
G. Nevzorova, I. Svetlitsa

ANIMATORS
G. Barinova, N. Bogomolova,
Y. Voliskaya, E. Maslova, M.
Motruk, A. Petrov, V. Morozov,
L. Nosirev, R. Ovivyan,
G. Sokolski

NARRATOR
Z. Gerdt

TECHNIQUE
Drawn animation

FORMAT
35mm, colour

LENGTH
20 seconds

YEAR
1962

WEBSITE
www.jovefilm.com

Fedor Khitruk was born in the Russian town of Tver in 1917 but has lived in Moscow since 1924. In 1931 his father was sent to Berlin on government business, which meant that Khitruk went to study at a school of commercial art in Stuttgart. Returning to Moscow in 1934, he was inspired to experiment with animation after he saw Disney's *Band Concert* at the 1935 Moscow International Film Festival. 'I dreamed of being an artist, actor and musician,' he says. 'Animation collects all of these professions together.'

In 1937 Khitruk began his animation career at the state-run animation studio Soyuzmultfilm, which was founded in 1936 as the only production company for Soviet animation artists. However, on the outbreak of the Second World War, Khitruk joined the army. Because he spoke German fluently he remained involved in post-war negotiations until 1948, when he finally returned to Soyuzmultfilm to work on feature films directed by such important figures as Ivan Ivanov-Vano.

Khitruk became a director in his own right in 1960, directing over 15 films, including *Story of One Crime* (1962), *Film Film Film* (1968), *The Youth Friedrich Engels* (1970) and *Lion and the Bull* (1983). He also made three films based on A.A. Milne's classic book, *Winnie the Pooh*. 'The idea behind them was simple: to screen a book which I loved so much,' he says simply. 'At that time I didn't know about the Pooh-serial made by Disney, though Woolie [Wolfgang] Reitherman [of Disney] did say he liked my version.'

Although Khitruk stopped making films in 1983, he remains passionate about the communicative power of the medium. 'The art of animation, which gives life to the inanimate, has the power to touch all people, both adults and children and to bring them together, transcending nationality and language,' he has said.

Khitruk is also convinced of the importance of education in animation, and he has been hugely influential in this field since 1956. Having observed the radical changes within the industry, he is slightly sceptical of the supposed benefits created by computer technology. 'There are still only few artists, such as John Lasseter, who master the computer as an artistic tool,' he explains. 'In most cases it is only a demonstration of the new technical possibilities of computer hardware.'

He served as the president of the Animation Commission USSR from 1962 to 1989 and was the vice-president of the leading animation body, ASIFA, from 1970 to 1980. He has also sat on the juries at many international festivals, from Hiroshima and Los Angeles to Zagreb, while he remains the honorary president of the Russian Animation Association. Khitruk is widely considered to be one of the most influential figures in Russian animation.

Story of One Crime (1962) marks Khitruk's directorial debut and was one of the first Russian films to be made specifically for an adult audience. Ostensibly telling the story of one man's struggle with his neighbours, the film portrays a society that is far from ideal, which is particularly remarkable given the political situation in Russia at the time.

TITLE
The Hand

STORY, SCREENPLAY, DIRECTOR AND ARTIST
Jiri Trnka

COUNTRY OF ORIGIN
Czechoslovakia

PRODUCERS
Kratky Film Praha, Cartoon and Puppet Film Studio

MUSIC
Vaclav Trojan

CAMERA
Jiri Safar

TECHNIQUE
Puppet animation

FORMAT
35mm, colour

LENGTH
19 minutes

YEAR
1965

WEBSITE
www.kratkyfilm.cz

JIRI TRNKA

Born in Plzen in the former Czechoslovakia in 1912, Jiri Trnka first became interested in puppetry at school because of his drawing teacher, who was also manager of the local modern puppet theatre. After graduating from the School of Applied Art in Prague, Trnka initially made a name for himself as an editorial illustrator, but he soon made other plans and opened his first puppet theatre at the Rokoko Hall in 1936.

Trnka's film career began in 1945, with the founding of the Trick Brothers Studio. In 1946 he won the Grand Prix at the Cannes Film Festival for one of his first cartoon films, *The Animals and the Brigands*. However, he quickly tired of cartoon-style animations because he disliked having to rely on other people, preferring to work on every aspect of a film himself.

His first puppet film was finished in 1946. 'We animated one of my older puppets, a dancer,' he said. 'She was gentle and articulate and moved beautifully, but the results gave an abstract impression. It looked well, but said nothing. Later we realized that a film puppet needs concrete situations, a story.'

Trnka turned to Czech fairytales and myths: his first feature film, *The Czech Year* (1947), was inspired by the country's folk traditions and superstitions and was internationally acclaimed for his artful animation of pieces of wood. For another early film he adapted Hans Christian Andersen's story, *The Emperor's Nightingale* (1948), and in 1953 he completed a puppet version of Czech mythology called *Ancient Czech Myths*. Most of his films feature music inspired by Czech folk songs, and none of his puppets were ever lip-synched because he believed that it was barbaric to try to make puppets 'talk'. Other early Trnka films include *The Novel With The Double Base* (1949) and *Bajaja* (1950).

His feature film of Shakespeare's *A Midsummer Night's Dream* (1959) took four years to complete but enjoyed little success at the box office. Disappointed by this unfavourable reaction, Trnka promptly immersed himself in painting and sculpture, making only another four puppet films, including the politically charged, *The Hand*, which he completed in 1965.

The Hand stars a downtrodden artist, a male puppet living in a totalitarian regime, who is dictated to by the figure of an ever-present, omnipotent Hand. The Artist is only allowed to create sculptures of the Hand, which eventually causes the death of the Artist. 'The hand is omnipresent', Trnka explained. 'It never made a difference between nationalities and forced every individual to do things he did not wish to do at his own will ... The victim could be anyone from ancient times, or Galileo Galilei, Oppenheimer at another time.' Ironically, after Trnka's death in 1969, he was given a state funeral by the Communist regime, while all copies of *The Hand* were confiscated and the film was banned for the next 20 years.

The Hand (1965) stars the puppet figure of 'the Artist', a downtrodden male living in a totalitarian regime and dictated to by 'the Hand' (both gloved and naked). Featuring Jiri Trnka's exquisite puppetry and animation, the film ends with the murder of the Artist by the Hand, which hypocritically goes on to organize a state funeral for him.

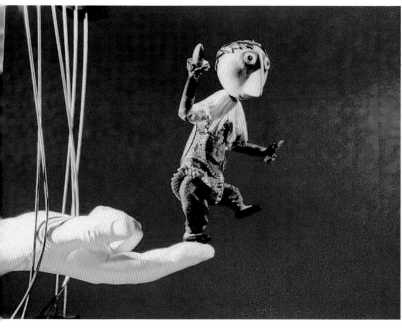
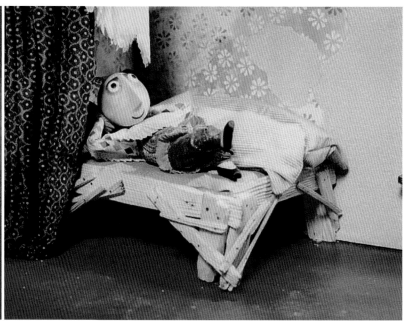
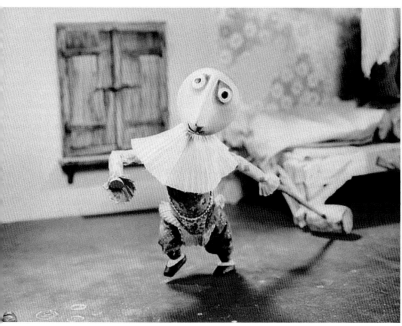

ANDREI KHRJANOVSKY

TITLE
There Lived Kozyavin

DIRECTOR
A. Khrjanovsky

COUNTRY OF ORIGIN
USSR

SCRIPT
L. Lagin, G. Shpalikov

CHIEF ARTIST
N. Popov

COMPOSER
G. Lukianov

CINEMATOGRAPHER
B. Kotov

SOUND
G. Martinok

EDITORS
M. Trusova, R. Frichinskaya

ASSISTANT DIRECTOR
M. Turanova

ASSISTANT TO ARTIST
G. Arkadiev

ANIMATORS
A. Petrov, A. Abarianov,
D. Ampilov, U. Yuzurin

PRODUCER
A. Zorina

TECHNIQUE
Drawn animation

FORMAT
35mm, colour

LENGTH
7 minutes

YEAR
1966

WEBSITE
www.jovefilm.com

Born in Moscow in 1939, Andrei Khrjanovsky graduated from the Soviet State Film School (VGIK) and was hired by the Russian state animation studio, Soyuzmultfilm, in 1965. There he worked with the legendary Russian animation director, Fedor Khitruk, who had a huge influence on his work.

Representing the new type of erudite director who emerged during this period, Khrjanovsky was an intellectual connoisseur of world art, literature and music. Disdainful of the animation industry's previous artistic and literary constraints, many of Khrjanovsky's films contain his veiled (and not so veiled) criticisms of the Soviet regime. His directorial debut, *There Lived Kozyavin* (1966), takes a critical look at state bureaucracy from the point of view of Kozyavin, an official who is prepared to go to ridiculous lengths to obey commands from above.

Two years later his film *Glass Harmonica* (1968), explored the confrontation between state and artist. Not surprisingly, this was seen as particularly controversial at the time and the film was shelved, being released only after *perestroika*. It was scored by the renowned Russian composer Alfred Schnittke, with whom Khrjanovsky collaborated on more than half of his films. The animators on this film, Yulo-Ilmar Sooster and Yuri Nolyev-Sobolev, were also among the most important artists of the Soviet underground.

Other of Khrjanovsky's films escaped being banned only because the censors misread their meaning. *Armoire* (1970) features a man moving all of his furniture into his wardrobe and living there. Khrjanovsky was portraying a man trying to hide from an unpleasant world – the censors, however, saw it as a critique of mediocrity. They got it wrong again with *King's Sandwich* (1985), based on a poem by A.A. Milne. While Khrjanovsky was trying to show how paying too much attention to trivialities causes chaos, the censors thought he was criticizing the country's lack of butter.

Hugely influenced by the writings and drawings of Alexander Pushkin, Khrjanovsky based three films on his work – *I'm Flying To You By Memory, I Am With You Again* and *Autumn* – and these were later released together in one full-length film, *Time I Love*. Khrjanovsky was always interested in promoting Russian culture, literature and history, using animation to merge artistic images and create films that were genuinely unique in style, tone and voice. Since the fall of the USSR, Khrjanovsky has made three more films as a producer and director, two of them being written by the Italian author, Tonino Guerra.

There Lived Kozyavin (1966) features the plight of Kozyavin, a lowly Russian official, who goes to ridiculous lengths to avoid disobeying a direct order from a superior.

TITLE
Made in Japan

DIRECTOR
Renzo Kinoshita

COUNTRY OF ORIGIN
Japan

SCRIPT
Hajime Tabe, Sayoko Kinoshita

ANIMATOR
Renzo Kinoshita

MUSIC
Taro Saito

PRODUCTION
Studio Lotus

TECHNIQUE
Cel Animation

FORMAT
35mm, colour

LENGTH
9 minutes

YEAR
1972

RENZO AND SAYOKO KINOSHITA

Born in Osaka in 1936, Renzo Kinoshita was a prolific and award-winning animation director of television programmes, such as the well-known *Geba Geba 90 Pun*, as well as commercials and pop promos. However, it was his independent, short animated films, such as *Made in Japan* (1972), *Japonese* (1977) and *Picadon* (1978), that brought international recognition for Renzo, his wife Sayoko and their production company, Studio Lotus.

Sayoko Kinoshita was born in Tokyo and graduated from the Plastic Arts Department of the Women's College of Fine Arts in 1966. She joined Studio Lotus in 1969, two years after it was founded and collaborated on both commercial and independent films with her partner Renzo. Meanwhile, the couple split the film work between them, taking on different responsibilities – Sayoko was mainly in charge of planning, scripting, animation and production, while Renzo worked on the key animation and direction.

With their insightful film *Made in Japan*, the Kinoshitas succeeded in predicting the current economic recession in Japan. The non-narrative film satirizes the 'economic animal Japan'. Sayoko comments: 'Our predictions came true, unfortunately and ironically. At the time both Renzo and I were very concerned and anxious about our country and about our people who seemed to make the economy their very first priority. Contrary to our country's policy "economy for economy's sake", we strongly expressed in our film that we should not only pursue profit.' Following *Made in Japan*, Renzo and Sayoko made another animation short entitled *Japonese*, which also depicted and satirized contemporary Japan. Another of their short films, *Picadon*, took the A-bomb attack on Hiroshima as its subject.

Throughout their lives and work the Kinoshitas pursued an underlying theme of peace. In 1981 they established ASIFA, Japan, the national branch of the Association Internationale du Film d'Animation, and in 1985 they founded the first ASIFA-endorsed competitive animation festival in Hiroshima. Renzo Kinoshita died in 1997, but Sayoko still runs the festival with its lofty but heartfelt aim of establishing world peace through international communication with different cultures.

Interviewed by Thomas Renolder for the ASIFA website www.asifa.net, Sayoko Kinoshita commented: 'Love and peace is not our slogan, but rather the spirit of the festival. The ASIFA was founded as an international association, not only for the development of animation, but also to seek world peace and be anti-war … Throughout its history the ASIFA has tried to enhance the communication between East and West even during the Cold War. Thus, the spirit of ASIFA and Hiroshima were united together to establish the first festival in 1985, which was the fortieth anniversary of the Hiroshima A-bomb.'

Made in Japan (1972) won the Grand Prix at the New York International Animation Festival in 1972. The film, a non-narrative short, parodies commercialism in Japan. A typical Japanese man sits in a small room (a metaphor for Japan) while various characters, each representing different aspects of Japanese society, enter one after another.

163

TITLE
Door

DIRECTOR
N. Shorina

COUNTRY OF ORIGIN
USSR

BASED ON A STORY BY
T. Ponomareva

PRODUCTION
Soyuzmultfilm Studio

SCRIPT
A. Studzinski

ART DIRECTOR
V. Dudkin

CAMERAMAN
Y. Kamenetsky

ANIMATORS
T. Molodova, M. Pisman,
S. Olifirenko, B. Shilobreev

SOUND
B. Filchikov

EDITORS
G. Filatova, A. Viatkin

VOICES
A. Barantsev, B. Novikov, M.
Krepkogorskaya, Y. Gromova,
V. Maschenko and The Parrot
Chika

DOLLS AND SETS
P. Gusev, O. Masainov,
V. Abbakumov, V. Grishin,
M. Koltunov, B. Petrov, N.
Barkovskaya, M. Chesnokova,
N. Menchukov

PRODUCTION
G. Khmara

TECHNIQUE
Drawn animation

FORMAT
35mm, colour

LENGTH
11 minutes

YEAR
1986

WEBSITE
www.jovefilm.com

NINA SHORINA

Born in Moscow in 1943, Nina Shorina was a popular child actress who first studied acting and then filmmaking at the State Film School (VGIK). 'Having studied documentary film, I knew I wanted to become a film director,' she explains. 'I was influenced by directors like Yoris Evens and Dziga Vertov, who turned me in the direction of pure cinematography, and the use of brave and pure language. But Soviet documentaries in those years had no connection with that kind of cinema. It destroyed Vertov and continued to destroy anything that was different from the ideological propaganda of those days.'

Hence Shorina began her first forays into animation: 'There, on the periphery of cinema, it was easier to breathe and create,' she says. Disliking drawing, she began to experiment with stop-motion films when hired by the state-run studio, Soyuzmultfilm in 1976. 'Wherever possible, I played with lights and shadows,' she explains.

Having made a series of films that upset the authorities, including *Fairy Tale About a Very Tall Man* (1983), she was reluctantly forced to concentrate on making children's films, such as *About Buka* (1984), a film opera based on her own fairytale, and the award-winning *Poodle* (1985). Just prior to *perestroika*, Soyuzmultfilm's administration approved *Door*, a script ostensibly about a boy repairing a door, believing it would be a film for children. However, the film Shorina delivered in 1986 was definitely for a grown-up audience, the first of a trilogy exploring the Soviet reaction to the dramatic political changes that were sweeping the nation. 'I saw it as a film about people whose minds have the mentality of closed doors,' she explains. 'My editor – back then the editor also played the role of censor – said that I could not even shoot the film, and if I did they would shelve it. They probably would have were it not for *perestroika*. The genie was out of the bottle.'

The next two films in this series, *Dream* (1988) and *Alter Ego* (1989), continued her explorations into the language of cinema and its relationship to experiments of form and style. *Dream* was in part inspired by a quote from novelist Fyodor Dostoyevsky, what he referred to as 'the tragedy of inaction' of the Russian intelligentsia. 'As I see it, style is the materialization of spirit,' Shorina says. 'Developing the language of animation, I brought it closer and closer to feature films. *Alter Ego* was a collage, a unity of nature or landscapes, actors, dolls, masks, and the real world of subjects. The Soviet environment stifled creative souls.'

Revelling in the relative freedom of the post-Soviet era, Shorina has since begun to direct live-action feature films. She is currently working on the film *Nitsche*, which is being shot in Moscow.

Door (1986) portrays the residents of an apartment block who are unable to reconcile themselves to using their building's front door, which had been broken for many years but was now fixed. Supposedly a children's animated film, Shorina was commenting on the inability of Soviet society to adapt to the new freedoms afforded them by *perestroika*.

JOHN LASSETER

TITLE
Tin Toy

DIRECTOR
John Lasseter

COUNTRY OF ORIGIN
USA

TECHNICAL DIRECTORS
William Reeves, Eben Ostby

SCRIPT/STORY
John Lasseter

SOUND
Gary Rydstrom, Sprocket Systems

TECHNIQUE
3D Computer Animation

FORMAT
35mm, colour

LENGTH
5 minutes, 8 seconds

YEAR
1988

John Lasseter was born in Hollywood in 1957 and grew up in Whittier, California, where his mother taught art. He began experimenting with cartoons and animation while he was in his freshman year at high school, when he was also studying art and drawing. He wrote to the Walt Disney Company for guidance on where and how to develop his passion. At that time, Disney was setting up a character animation programme at the California Institute of the Arts (CalArts), a centre for studying art, design and photography, and Lasseter became the second student to be accepted into their start-up programme. He spent four years at CalArts, where two of his animated films, *Lady and the Lamp* (1978) and *Nitemare* (1979), won Student Academy Awards in 1979 and 1980 respectively.

During his summer holidays Lasseter apprenticed at Disney, and on graduating in 1979, he landed a position at the Studio's feature animation division. During his five-year stint with Disney, he contributed to films such as *The Fox and the Hound* (1981) and *Mickey's Christmas Carol* (1983). Inspired by Disney's ambitious and innovative film *Tron* (1982), which used computer-animated visual effects, Lasseter teamed up with fellow Disney animator Glen Keane to experiment with computers. The resulting work was a 30-second test piece, based on Maurice Sendak's book *Where the Wild Things Are*. The film showed how traditional hand-drawn character animation could be successfully combined with computer-generated camera movements and environments.

In 1983, at the invitation of Ed Catmull, co-founder of Pixar, Lasseter visited the company's computer graphics unit, which was then part of Lucasfilm. Seeing the enormous potential that computer graphics technology held for transforming the craft of animation, he left Disney in 1984 and joined Pixar. Working closely with supervising technical director, Bill Reeves, Lasseter came up with the idea of bringing a pair of desk lamps to life: *Luxo Jr.* was born. The first film to garner Lasseter an Academy Award nomination in 1986, it was followed by a number of short films, including *Red's Dream* (1987) and *KnickKnack* (1989), both of which met with critical acclaim. Lasseter received his first Academy Award in 1989 for *Tin Toy*, which won the Best Animated Short Film category.

'Computer graphics technology makes a clumsy tool compared with the unencumbered flow possible with pencil and paper. However, great animation art can be made with any tool once the artist gains a command of it,' says Michael Scroggins, director of the computer animation labs at CalArts. 'The successful transition from traditional animation tools to the new technology of 3D computer graphics made by John Lasseter and his colleagues at Pixar is a positive example of how successful adaptation can be.'

Lasseter is certainly something of a master of the medium: *Toy Story*, his first feature, was the highest grossing film of 1995, for which he received a Special Achievement Academy Award in 1996. Since then, he has also directed *A Bug's Life* (1998) and *Toy Story 2* (1999), and he is the Executive Vice President in charge of all creative work at Pixar.

Tin Toy (1988) tells the tale of Tinny, a tin toy trying to get the attention of a baby, who is surrounded by toys and spoiled for choice. *Tin Toy* was the first computer-animated film to contain a character with life-like, bendable limbs and facial expressions. The challenge for the film's makers was to balance a real-life look and feel with a cartoon aesthetic.

MARK BAKER

TITLE
The Hill Farm

WRITER AND DIRECTOR
Mark Baker

COUNTRY OF ORIGIN
UK

SOUND
Danny Hambrook

MUSIC
Julian Nott

EDITOR
Annie Kocur

CAMERA
Danny Boon

VOICE
Paul Bingley

PRODUCTION
National Film and Television School

TECHNIQUE
2D animation

FORMAT
35mm, 1:1.85 Widescreen

LENGTH
18 minutes

YEAR
1988

WEBSITE
www.astleybakerdavies.com

'My first interest in animation was to do with the technique itself,' says Mark Baker. 'During a childhood summer holiday in France, my sister and I made a kind of home-made film with drawings on paper (we didn't use a camera). After that holiday, when we returned home, we found out a bit more about animation and, using my father's 8mm cine camera, we each made a short piece of animation film. When this exposed film came back from the labs and was projected, it was one of the most exciting things we had ever seen – our drawings were actually moving!'

Born in London in 1959, Baker studied animation at the prestigious National Film and Television School, and he remains adamant that this is the medium for him. 'What I really like about animation is that it's a complete cheat. Drawings and puppets can't really move or have feelings, but somehow, through animation, we believe they can,' he says. 'In fact all filmmaking is obviously a "cheat" in the same way, because every shot is set up and every line is written. But what is particularly interesting about animation is that the "cheat" is so blatant. We don't pretend that what you are seeing on screen isn't a drawing or a lump of plasticine and yet the illusion can still be pulled off. But I love all types of film – live action, documentary and animation; I just happen to enjoy making animation the most.'

Baker's graduation film, *The Hill Farm*, took three years and £18,000 ($25,000) to complete, but the time and effort paid off: the film won prizes all around the world, including a BAFTA, an Academy Award nomination and the Grand Prix at Annecy in 1989. He continues to create short films, including *The Village* (1993) and *Jolly Roger* (1999). 'The great thing about making short animation films is that it's an extremely comfortable method of filmmaking,' he says happily. 'Unlike live action, you don't have to get up at dawn, stand in the rain, or carry heavy equipment around. Instead, you can make the entire film working reasonable hours, in a nice cosy studio, with a mug of coffee to hand. Well, that's the theory anyway ... somehow it never seems to work out that way.'

Baker also works on commercial projects, having been signed to various studios in London over the years. In 1994 he formalized a regular collaboration with fellow animator Neville Astley, forming the studio that is now known as Astley Baker Davies. 'The good thing about commercial work is that it involves solving someone else's problem,' he says. 'The best art directors and copywriters that I've worked for have a very strong idea about what they want and it's my job to realize this. Very often this pushes my design and animation in directions that I wouldn't otherwise go, so I always come out at the end of a commercial job feeling that I've got stronger.' Commercial campaigns to date include advertisements for IKEA and Kraft Cheese, while the studio also created and co-directed *The Big Knights*, a series of 13 short films shown on BBC television in 2000.

The Hill Farm (1988) features three groups of people – farmers, campers and hunters – and examines how they use the same area of countryside – nurturing it, admiring it or destroying it. A fierce storm drives all the characters together before they can instead get on with their normal lives again. The film features no dialogue, relying instead on sound effects and music.

TITLE
The Exciting Love Story

STORY, DESIGN, ANIMATION AND DIRECTION
Borivoj Dovnikovic Bordo

COUNTRY OF ORIGIN
Croatia

BACKGROUNDS
Pavao Stalter

MUSIC AND SOUND EFFECTS
Davor Rocco

EDITOR
Tea Brunsmidt

CAMERAMAN
Valerija Radanovic

PRODUCTION
Zagreb Film, Zagreb

TECHNIQUE
Cel animation

FORMAT
35mm, colour

LENGTH
5 minutes, 49 seconds

YEAR
1989

BORIVOJ DOVNIKOVIC BORDO

Born in 1930 in Osijek, Croatia, Borivoj Dovnikovic knew that he wanted to be involved with animation from an early age. 'When I was a child there was no television, but occasionally we were able to watch American cartoons in the cinema, as prologues to feature films,' he explains. 'While feature films were black and white, the cartoons sputtered of colors, which utterly enraptured me. Even then I was dreaming about the possibility of making cartoons in the future.'

Having moved to Zagreb in 1949, Bordo (Dovnikovic's professional and personal nickname) studied for less than a year at the Academy of Fine Art before joining a group of caricaturists at the satirical weekly, *Kerempuh*. They went on to produce Yugoslavia's first animated film. 'I became an assistant to Walter Neugebauer, the force behind *Kerempuh* and designer and animator of the future film,' he says. 'Neugebauer was very well known in the country as a comic strip designer and had some modest experience in animation, but for us, his collaborators, it was our first contact with the discipline. We all enthusiastically started learning the skill and after one year, in 1951, we finished *The Big Meeting*, the first Croatian/Yugoslav independent cartoon film.'

Obsessed with his new-found artistic medium, Bordo has never looked back, working as a designer and animator until 1961 and from then working to produce versions of his own artistic vision. That's not to say that he excludes any other creative outlet: 'I am a caricaturist, illustrator, comic strip designer, graphic designer and animation filmmaker (script-writer, designer, animator and director),' he says. 'From the 1950s I have worked in all those fields, though of course I have mostly worked in animation, which still offers me the most creative satisfaction.'

Bordo is a prime example of someone who straddles the divide between animation as exemplified by Walt Disney and more experimental figures, such as Oskar Fischinger. 'I was initially inspired by Disney, but in the second part of the 1950s, parallel with the evolution of Zagreb animation, I continued to work in the style of my newspaper cartoons,' he says. 'At Zagreb Film [the national production company that supported much of Bordo's filmmaking] we were creating in completely different ways from our old father Walt Disney. Jaques Tati is my favourite feature film director, and that's how I would like to make feature films – as an animator.'

Bordo was one of the key figures behind the founding of the Zagreb Animation Festival in 1972, working as the festival director for many years. 'I wanted the festival to be a meeting place for all animation artists, filmmakers and fans, with a big emphasis on "art",' he says. Currently writing his autobiography – 'the history of Zagreb animation, seen from the inside' – he remains quietly confident about the growing status of animation. 'I am an optimist,' he says. 'I firmly believe that with the growing availability of videos and DVDs, people will build personal film libraries with their favourite artistic animated films, just as they have libraries of books today.'

'The main impulse behind **The Exciting Love Story** (1989) was a play on the phenomenon of animated film,' says Bordo (Borivoj Dovnikovic). Created as traditional cel animation, the screen is divided into various sections. Starring the two characters, Mickey and Gloria, this is a simple love story with the traditional, happy ending.

RICHARD KENWORTHY

TITLE
The Littlest Robo

DIRECTOR
Richard Kenworthy

COUNTRY OF ORIGIN
UK

CO-WRITER AND ANIMATOR
Gideon Baws

MODELS AND ANIMATION
Chris Harding

PRODUCTION
Royal College of Art, UK

VOICE ARTIST
Kurt Wagner

MUSIC
Old Man Waltz by Calexico

OTHER CREDITS
Caroline Espenhalm, Ruth Lingford, Ima Louth, Mark Tait, Jason Goves, Meg Leonard, Peter Mellor

TECHNIQUE
Drawn animation, 3D computer models

FORMAT
16mm, colour

LENGTH
8 minutes

YEAR
1999

WEBSITE
www.shynola.com

'I used to compile tapes of animation by filming the late-night screenings on Channel 4 simply because I found them fascinating,' says Richard Kenworthy. 'But for some reason I never thought I should actually try it. It appeared to be something that only boffins did, and I thought that to physically make an animation would betray and destroy the magic of being the audience rather than the creator.'

Born in Halifax, UK, in 1975, it was while studying illustration at the Kent Institute of Art and Design that Kenworthy relented and took a short course in animation 'just out of curiosity'. And while the rest isn't exactly history, deciding to live with three of his fellow students led to him co-founding what is already one of the most celebrated commercial animation collectives of the 21st century, Shynola. For years the four (Kenworthy, Chris Harding, Gideon Baws and Jason Groves) lived and worked in the same house in Muswell Hill, London, although in mid-2003 they relented and moved to a more conventional office space in east London.

'We have no real structure when approaching jobs, it is a casual affair and one that baffles us,' Kenworthy admits cheerfully. 'We don't really understand why it works so we don't try to question or prod it. Some of us are definitely more talented in certain areas, while there are certain aspects of the process which I, for instance, find the most appealing. But the driving force is a pride in the quality of our output, so if any of us have to do a job we don't like or find hard, we do it if we know that it will help the cause.'

To date, Shynola have created advertisements for companies such as Orange, NatWest and Nike, and they have also created memorable pop promos for acts including Unkle, Radiohead and Lambchop. Kurt Wagner of Lambchop actually provided the voiceover for their one short film, *The Littlest Robo*. 'We had been to see Lambchop in concert and Kurt had an amazing rapport with the audience,' Kenworthy says. 'He has a hushed, deep, warm and soft voice when he performs which seemed perfect for the film. I managed to get in touch with him and though I think he was a little baffled, he agreed to do it.'

Plans are currently underway to create another short film, with a view to working on a feature-length film some time in the future. 'The quality of the work we are offered regularly appals us, so I imagine that this may happen soon,' says Kenworthy who concludes wryly: 'I wouldn't necessarily call our work "art". Perhaps "not shit" would be more apt.'

The Littlest Robo (1999) tells the poignant tale of a lonely boy living in a remote location with his workaholic father. The boy builds a robot to be his friend and everything goes well until there is an accident at home. With the father absent as usual, the robot gives up its own life to save the boy.

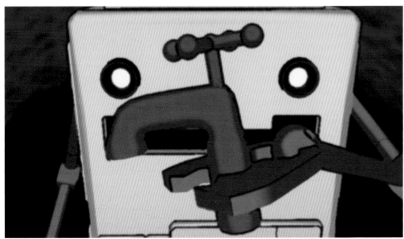

TITLE
Father and Daughter

DIRECTION, DESIGN AND STORY
Michael Dudok de Wit

COUNTRY OF ORIGIN
Holland/UK

PRODUCERS
Claire Jennings, Willem Thijssen (co-production)

PRODUCTION
A British-Dutch co-production by Cloudrunner Ltd., CinéTé Filmproductie bv

ANIMATORS
Michael Dudok de Wit, Arjan Wilschut

BACKGROUNDS
Michael Dudok de Wit

MUSIC
Normand Roger in collaboration with Denis Chartrand

SOUND
Jean-Baptiste Roger

TECHNICAL DIRECTION
Spider Eye Ltd. Compositing by Alistair Beckett, Nic Gill

TECHNIQUE
Pencil and charcoal, digital colouring

FORMAT
35mm, BETA, colour

LENGTH
8 minutes, 30 seconds

YEAR
2000

WEBSITE
www.dudokdewit.com

Born in 1953, Dutch animator Michael Dudok de Wit was inspired by East European short animated films to study animation at the West Surrey College of Art (now the Surrey Institute) at Farnham in the UK. 'I also always loved comic strips, especially continental ones, for their combination of illustration and storytelling,' he says. 'Animation was an obvious choice because, on top of the illustration and storytelling potentials, it gives the opportunity to play with timing and with sound and music. Another reason for my interest in the discipline is that at my first animation festival at Annecy in the mid 1970s, I watched the films passionately, while I also looked at the filmmakers. They were generally dedicated, creative, open-minded and honest people, and I felt attracted to them.'

Dudok de Wit's graduation film, *The Interview* (1978), in which a little animal tries, with little success, to interview other creatures, brought him into contact with commercial animation studio Richard Purdum Productions, and landed him his first professional job. Since then, Dudok de Wit has worked on a freelance basis on hundreds of commercial projects, creating advertisements for the likes of Heinz, Volkswagen and AT&T. He has also designed book illustrations and regularly lectures on animation around the world, in art colleges such as the Royal College of Art and National Film and Television School, both in the UK, Harvard University in the US and Kassel University in Germany.

However, his passion remains his work on short, personal films. 'For me there is a large difference between being a professional commercials director and an independent filmmaker,' he says. 'For commercials your creativity is much more based on meetings with clients, agencies and colleagues. For your own film you choose to delve into your elusive personal source of creativity. Or at least you try.'

'Short films can be like poems: intense, timeless and highly personal,' he continues. 'I just love them.' His films such as *Tom Sweep* (1992) and *The Monk and the Fish* (1994) have scooped up awards from various organizations, while *Father and Daughter* (2000) won both an Academy Award and a BAFTA for the best short animated film of 2001. While Dudok de Wit's subject matters may differ, all his films share a timeless beauty in their illustrative style, and great attention is paid to the sound and music design (none of them have dialogue). 'I had no particular desire to create a fashionable or "cutting edge" look, I just wanted the visuals to be beautiful and understandable,' he says firmly. 'I can admire a film with an ugly and shocking design, but in my own drawings I enjoy a degree of simple elegance. In my drawings I am extremely sensitive to atmosphere, light and shadow, and space. The abundant use of shadows has become my favourite visual technique.'

Father and Daughter (2000) tells the story of a little girl who watches her father sail out to sea. She then spends the rest of her life longing for his return. Set against large, open landscapes inspired by Dudok de Wit's native Holland, the story is told simply and elegantly and is heartbreakingly poignant.

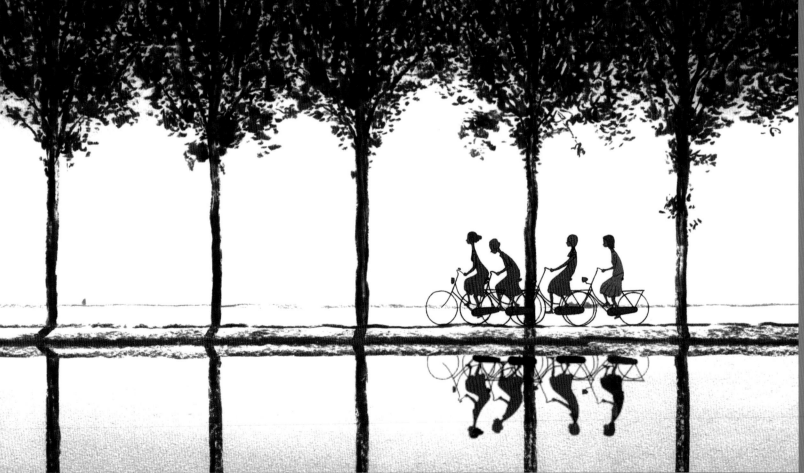

TITLE
Dog

DIRECTION, ANIMATION, PRODUCTION, PUPPET AND SET DESIGN, STORY AND LIGHTING
Suzie Templeton

COUNTRY OF ORIGIN
UK

SETS AND PROPS
Suzie Templeton, Ian Templeton, Annie Templeton, Jonny Templeton

PRODUCTION
Royal College of Art, UK

VOICES
Tony Fish, Josh O'Keefe, Bill Homewood

HUMAN ARMATURES
MacKinnon & Saunders Ltd

PRODUCTION ASSISTANT AND CHARCOAL ANIMATION
Becalelis Brodskis

ORIGINAL SCORE
Kostas Kyriakidis

SOUND DESIGN
Tim Barker

EDITING
Tony Fish

TECHNIQUE
Stop-motion puppet animation

FORMAT
35mm, Beta SP, digibeta, colour

LENGTH
5 minutes, 38 seconds

YEAR
2001

SUZIE TEMPLETON

Suzie Templeton became interested in animation when she was a child. 'My brother Jonny had an old Super-8 camera and we used to do things like try to make it look like there was an earthquake in the garden,' she says. 'We also did special effects for his war film, *Jaws of Death* (1977), but then I must admit I forgot all about animation.'

Templeton actually studied science at university – 'I didn't think I was good enough to do art, I still don't really,' she says. In fact, it wasn't until she was in her mid-twenties that her desire to be creative finally got the better of her. 'I was working as an English teacher in an orphanage in India and my mum sent me a picture of *Wallace and Gromit* and I thought I'd love to try model animation,' she explains. She went on to receive a first class degree in Animation from the Surrey Institute of Art and Design and a masters degree from the Royal College of Art, UK.

Templeton's films certainly verge on the dark side: claustrophobic atmospheres and intense characterization are common in her work. Her films have won plaudits and awards from all over the world: *Stanley* (1999) scooped 15 international film awards, *Dog* (2001) a further 16, including a BAFTA. However, she has found it hard to find a commercial niche. 'It seems that people find my work too dark to see a commercial application,' she explains. 'In an ideal world I'd like to continue to make my own films, but I haven't quite figured out how to make a living from it yet.'

'For me, it's vital to distil the essence of the idea and to concentrate continually on that essence,' she continues. 'Short films allow small, forgotten moments to come to the forefront rather than the heroic journeys of so many features. The short form encourages the expansion of the minute rather than the condensation of the huge.'

Having worked as a visiting artist at the California Institute of the Arts in Los Angeles, US, Templeton is nonetheless reluctant to describe her work in terms of 'art'. 'It's difficult to say because it's such a loaded word. My films don't fall into the category of "art film" but they are not just illustrations of stories. They are creations born of obsession and will, which have a life of their own beyond my intention. Without my permission they expose me and betray my confidence. Perhaps this is inevitable when working in such a solitary and intense way, distilling a year's life into a few minutes of film.' She is currently awaiting final funding for her next film proposal, a half-hour adaptation of *Peter and the Wolf*.

Dog (2001) tells the tale of a young boy and his father trying to comfort each other after the death of the boy's mother by resolutely not talking about their grief. Unremittingly bleak, the death of the elderly family dog serves only to make matters worse.

TITLE
What is That

DIRECTION AND DESIGN
Run Wrake

COUNTRY OF ORIGIN
UK

SOUND
Run Wrake and Premiere

TECHNIQUE
Hand-drawing, DV, digital photography, Photoshop, After Effects and Bryce 3D

FORMAT
Quicktimes into Beta SP via Photoshop, colour

LENGTH
3 minutes, 17 seconds

YEAR
2001

WEBSITE
www.runwrake.com

RUN WRAKE

Born in Aden in the Yemen in 1963, Run Wrake began to experiment with animation after seeing the promo *Close to the Edit* by Art of Noise. 'Another catalyst was some animated loops I saw on the 1970s UK music television show, *The Old Grey Whistle Test*,' he says. 'I was studying graphic design at Chelsea School of Art and I began to experiment with a Super-8 camera and off-cut pads from printers, eventually progressing to 16mm. However, Chelsea had no editing facilities, so early films were cut as shot.' Wrake went on to learn the mechanics and technicalities of animation while studying for a masters degree at the Royal College of Art, UK.

Inspired by animation pioneers such as Len Lye, Oskar Fischinger, the Fleischer brothers and Jan Svankmajer, Wrake also mentions Dada, 1930s Russian graphics, Pop Art and graffiti as huge influences on his work. 'I describe my work as collage, juxtaposing images, movement and sound over time,' he says. 'I am interested in using a narrative similar to the kind you have with instrumental music, as opposed to the more traditional "story" based narrative. I usually start with the soundtrack, and create pictures and animation to illustrate the sound, hopefully engaging the viewer and taking them on a journey where you're never sure what is coming next.'

During his final days at the RCA Wrake was approached by a representative from Channel X. This led to his first commercial work, the title sequence for the television show *Jonathan Ross Presents*. He remains based in London, where he works on commercials for the production company Bermuda Shorts. He has created promos for acts such as the Stereo MCs and Howie B, while he also continues to enjoy working on personal projects.

His first short film, *Jukebox* (1994), was financed by the UK's influential Animate! scheme. Wrake professes to enjoy the oportunity short films offer him to run wild with his explosive imagination, free from commercial restraints. Another film, *What is That* (2001), came about simply as a means of pleasing himself, and shows his trademark use of bright, often garish colours and semi-grotesque characters: 'I started by creating the beginning of the track using various samples from long-forgotten LPs and then adding animation,' he explains. 'I didn't really have an agenda, pictures were made and animated to the sound with a view to making people laugh on one level, to tempt the viewer to look for a meaning that may or may not be there on another. Towards the end, the character Meathead, who has been present in my work for years, started to enter into a narrative, storyline direction, so I decided to end the film as a short, a prelude to a longer, more traditionally narrative piece which is one of my ambitions for the future.'

What is That (2001) features Run Wrake's abstract but colourful characterizations, including the hero Meathead, in a deliberately non-narrative film.

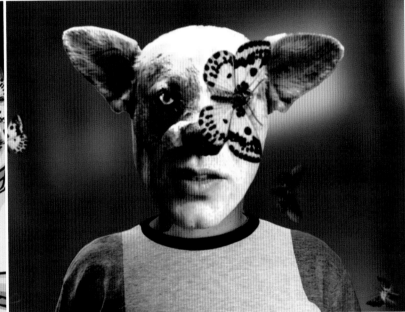

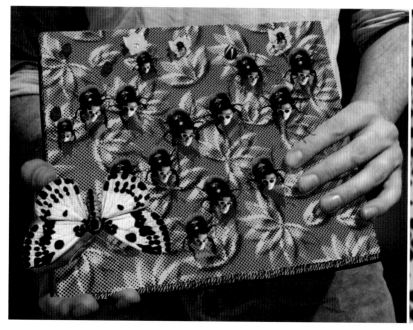

189

INDEX

190

CREDITS

Certainly, this book would not have been possible without the tireless help and support of a number of key figures, all of whom have been overwhelmingly generous with their time and expertise. In particular, we would like to thank David Curtis of the British Artists Film and Video Collection for putting up with numerous emails and visits and for patiently answering all manner of stupid questions. Cindy Keefer and Larry Cuba of the iotaCenter in Los Angeles who have been similarly long-suffering (www.iotaCenter.org) while Cecile Starr graciously supplied expert assistance and support (contact Cecile for information on the availability of the films of Mary Ellen Bute and Alexeieff and Parker at 35 Strong Street, Burlington, VT 05401, USA or on +(802) 863 6904 or at suzanne.boyajian@gte.net). Robert Haller of Anthology Film Archives in New York was also wonderfully helpful. Our special thanks and thoughts are with the family of Stan Brakhage, who sadly died during the publication of this book.

Our sincere thanks go to: Sara Álvaro, Zoe Antoniou, Dick Arnall, Charlotte Bavasso, Ned Beckett, Roanne Bell, Adam Boulter, Patrick Burgoyne, Mara Carlyle, Paula Carson, Kate Clarke, Peter Clarke, Jane Colling, Roman Dergam, Janeann Dill, Colette Forest, Yoko Fukuda, Pinky Ghundale, Lucy Glyn, Liz Graham, Keith Griffiths, Robert Haller, Fedor Hitruk, Tessa Ingham, Will Ingham, Clare Kitson, Martin Kublák, Jo Lightfoot, Richard Llewellyn, Mathew March Smith, Vladimir Morozov, Cary Murnion, Branko Novakovic, Chris O'Reilly, Plaid, Sian Rees, Laetitia Rouxel, Michael Scroggins, Christian Seidel, Barbora Souckavá, Mike Sperlinger, Hélène Tanguay, Andrew Thomas, Gary Thomas, Andrew Turner, David Verrall, Joan Borsten Vidov, Justin Vir, Warp Records, Evan Webb, Lynne Williams, Rodney Wilson, John Whitney Jnr. and, of course, all of the filmmakers themselves, who have without exception been a joy and a pleasure to deal with.

Special thanks also to Emma-Kate Gale from Nathan.

Quote from Dr Janeann Dill on p22 is from her forthcoming publication *Jules Engel: Image in Motion, A Critical Biography* (John Libbey Publishing, London, Sydney, Paris).

The authors and publisher would like to thank all the filmmakers who have given their permission to print material in this book. Every effort has been made to ackhowledge and contact the owners of copyright material, and to trace all original copyright holders. In the event that any changes should be made to the acknowledgements, the owners should contact the publisher who will make corrections for any future editions.

An accompanying DVD features 29 of the films (or extracts of them) that are featured in this book. The animators included are: Erica Russell, Insertsilence, Paul Glabicki, Norman McLaren, Tomioka Satoshi, Tim Hope, Pleix, Alex Rutterford, Han Hoogerbrugge, Jean-Luc Chansay, Jan Svankmajer, George Griffin, Caroline Leaf, Yuri Norstein, Stuart Hilton, Philip Hunt, Paul Driessen, Paul Bush, Jonathan Hodgson, Johnny Hardstaff, Lev Yilmaz, Fedor Khitruk, Andrei Khrjanovsky, Mark Baker, Borivoj Dovnikovic Bordo, Richard Kenworthy, Michael Dudok de Wit, Suzie Templeton and Run Wrake.

Total playing time is approximately 2 hours.
DVD produced by Push Media Group.
Title animation on the DVD by Andy Potts.